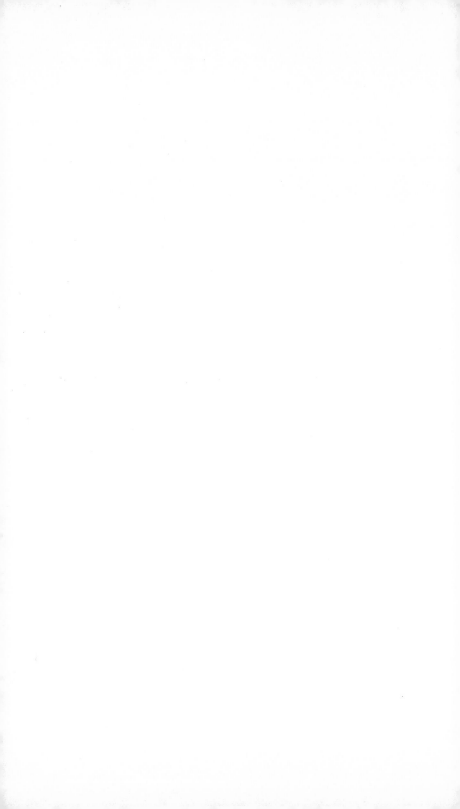

Gauguin's Letters from the South Seas

Paul Gauguin

Translated by Ruth Pielkovo
Foreword by Frederick O'Brien

DOVER PUBLICATIONS, INC.
New York

Published in Canada by General Publishing Company, Ltd., 30 Lesmill Road, Don Mills, Toronto, Ontario.
Published in the United Kingdom by Constable and Company, Ltd., 3 The Lanchesters, 162–164 Fulham Palace Road, London W6 9ER.

This Dover edition, first published in 1992, is a revised republication of the work originally published by William Heinemann Ltd., London, in 1923, under the title *The Letters of Paul Gauguin to Georges Daniel de Monfreid*. A new selection of artwork has been made for this edition.

Manufactured in the United States of America
Dover Publications, Inc., 31 East 2nd Street, Mineola, N.Y. 11501

Library of Congress Cataloging-in-Publication Data

Gauguin, Paul, 1848–1903.
 [Correspondence. English. Selections]
 Gauguin's letters from the South Seas / Paul Gauguin ; translated by Ruth Pielkovo ; foreword by Frederick O'Brien.
 p. cm.
 "A revised republication of the work originally published by William Heinemann Ltd., London, in 1923 [under title: The letters of Paul Gauguin to Georges Daniel de Monfreid]"—T.p. verso.
 ISBN 0-486-27137-4 (pbk.)
 1. Gauguin, Paul, 1848–1903—Correspondence. 2. Painters—France—Correspondence. I. Monfreid, Daniel de, 1856–1929. II. Title. III. Title: Letters from the South Seas.
ND553.G27A3 1992
759.4—dc20
[B] 92-737
 CIP

FOREWORD
BY FREDERICK O'BRIEN

A decade ago I began to live in the lonely places in the South Seas where Gauguin passed the last dozen years of his tortured life, and where he died in wretchedness. I had as neighbors both in Tahiti and in the Marquesas Islands men and women, white, native and Chinese, who had known the painter. Few of them knew anything of his fame or his career, and so they spoke of him only as a strange artist, a friend, an enemy, or a lost soul. He had been dead ten years when I came upon his former habitat, yet his servant recalled him vaguely, his mistress apathetically, the trader admiringly, one missionary factually, and another bitterly, and a chief with regret.

I searched for his grave on Calvary, the lonely hill above the village in which he died alone, but it was not marked. Coconuts grew in that neglected spot, and the hibiscus was blood-red on the ominous earth. Somewhere in the half-acre was the dust of Gauguin which perhaps nourished the living beauty of the blossoms as his art had revived humanity in painting. To the last breath he had been a rebel against convention in life and art, and at least his body must pay the penalty of obscurity even in death, though his soul spoke from his canvases all about the world. But even these are a few only. It may be that the effect of his attitude towards art and life on his contemporaries and on succeeding generations shall be greater than his actual achievements, but these were not striking, and are almost forgotten except by the scattered owners of his pictures.

Gauguin's whole life as a painter was an outcry, almost a curse, against materialism, against accepted success; against laws, morals, money, critics and clerics. Yet the bulk of his letters herewith are desperate pleas for a little money; for enough to keep body and soul together, and for materials for

painting. Contented to have had fifty dollars a month and to have let anyone else make the profits, the artist was condemned to go months without a cent, to beg, and to work as a day laborer for his bread.

He was a tortured soul. He could not control his fierce appetites, and his body decayed for many years, so that when he died in Atuona, it was merely the breaking of a cord long worn almost to severance. But his courage was unfaltering. Harassed by policeman and priest, afflicted by terrible pain, in a faraway isle where his pictures were mad trifles to his fellows, with not a single human being who understood and cared for him, he fought every weakness or condition that interfered with his painting.

He was a tremendous individualist; an example of strength against the powers of disintegration, of organized society, hardly to be found in modern years. He abandoned one by one every hold on ordinary things in order to be the savage he made his goal, and despite the certainty that he would not survive the attainment.

Gauguin hated what life has come to mean in civilization. He spilled his energy in bitter blows against the steel shield of society, and bruised his spirit continually in vain struggles against realities, which he tried to prove ghosts. He was faulted to a degree that rendered him absolutely unfit to be a stone in the structure, and so rejected but rejoicing fiercely in his separateness, he made himself into a monument of isolated and mysterious personality.

To me he is one of the most heartening men I know of. As a painter he was absolutely necessary to his age, which was fast hardening into a wretched scientific precision, and which had abandoned simplicity and breadth. As a human being, he evinced an incredible aversion to the machine efficiency that he thought was destroying the race, and he fought this threat of annihilation—as he believed—with a tenacity and an unselfishness that must light a flame in the hearts of all thinkers, though it killed Gauguin in middle age. Unable to adjust himself to anything about him, either in Europe or in the South Seas, he yielded only to death, and that stole upon him as he was smiling at his own plight.

ILLUSTRATIONS

Self-Portrait, 1896

PAUL GAUGUIN—AET. 1–43

The letters of the great painter Paul Gauguin, to his friend and fellow artist Georges Daniel de Monfreid, reveal one of those deep friendships which, whether existing among those distinguished in the world of letters or of art, or among more simple and less gifted individuals, seem to mark its possessors with a certain vivid fascination. It was a friendship not romantic in its outer aspects, and barren of fervent protestations—yet to Gauguin it meant, without exaggeration, his artistic life. For Daniel de Monfreid was the man who made what little ease and comfort he ever had in the South Seas, possible. He was his friend, his banker and his counsellor. He interviewed dealers, dunned creditors, sold his friend's pictures and exhibited them in his own studio; ran errands for him, provided him with everything, from artists' materials to flower-seeds and shoes and strings for his mandolin. And without his help Gauguin's life in the South Seas could barely have lasted out a year.

Gauguin's work, as he himself realised, is shadowed by the tragedy of unfulfilment. His was not a completed art, for he never gave to the world what he might have given, had the circumstances of his life been more fortunate. In this he himself may have been partly to blame. He lacked the knack of making useful friends. And he lacked the worldly cleverness of turning to his own advantage the vanities and the pretensions of the artistic powers of his day. For that he was too proud, and perhaps, too contemptuous.

"*Il est extraordinaire qu'on puisse mettre tant de mystère dans tant d'éclat.*"* So Mallarmé wrote of Gauguin's painting. And the words are

*It is extraordinary that he is able to invest so much brilliance with so much mystery."

true, not of his art only, but in a way of his life also—that unquiet restless existence, curving so topsy-turvily past the uneventful and outwardly placid lives of his contemporaries. It was a curious fate which led the rich and pampered boy to those years of service in the French Merchant Marine, to the luxury and respectability of a French stockbroker and *"père de famille,"* to the drab squalor of a shabby Bohemian, haunting the cafés of the Quartier, a hanger of advertisements of the Gare du Nord *"pour le sauver de mourir de faim,"** and from that, at last, to the embittered exile ending his days on an obscure island of the South Seas.

His life has already taken on the faint and wavering outlines of a legend, so far removed were its currents from all the ordinary ways of living; but its circumstances and, most of all, the curious personality of this extraordinary man, afford, to those whose minds quicken with the rarer and more uncommon aspects of the human spectacle, a troubling and exhilarating interest.

Until within the past two years Gauguin was, in America, hardly a name. A few artists knew of him, and among those fortunate enough to have seen the best of his work his genius was rarely questioned, though his paintings then, as now, are probably too exotic, too full of sinister dissonances, to be more than tolerated by the average observer. Yet his fame is growing, and the manner of its growth is somewhat ironical. For it was the appearance of a novel, based upon a version of Gauguin's life, that, becoming a best-seller both in England and America, first directed the thoughts of the general public towards him. Since then the translation of *Noa Noa,*** a rather idealised version of his Tahitian life, written in collaboration with Charles Morice, the art critic, has sharpened this attention until now Gauguin, the mythical South Sea artist, is vividly interesting to people of many sorts.

Cézanne, van Gogh and Gauguin were the three great leaders of that new art which, following upon the enchanting colour-harmonies of the Impressionists, has had so profound an influence upon contemporary painting. But from the first two, despite their somewhat similar theories of technique, Gauguin has always seemed apart, differentiated by an angle of vision, by a mysterious and bizarre poetry in which they did not share. It was involuntary, and he presents a bitter and lonely figure—lonely in death as in life.

Almost from the first Cézanne and van Gogh were hailed as Masters. Fame came to them, and the sweet and human rewards of victory. But not for Gauguin; a little friendship he had from men whose names are now among the glories of French art, but many of whom were then struggling like himself, and that was all. His work seemed to awaken a certain personal animosity, no less among the public than among the critics and painters

*"To keep from starving."

**Gauguin, *Noa Noa: The Tahitian Journal*, Dover Publications, Inc., 0-486-24859-3.

themselves. *"Son oeuvre est révoltant de grossièreté et de brutalité"** wrote Camille Mauclair, one of the fashionable critics of the day. And the public greeted his exhibitions with jibes and derisive laughter.

Gauguin's life and ancestry were full of disturbing improbabilities. Once in speaking of his youth, he said, "If I told you that on my mother's side I am a descendant of a Borgia of Aragon, the Viceroy of Peru, you would say that it is not true and that I am pretentious." Yet such was the case.

His mother, Aline Marie Chazal, was the daughter of Flora Tristan, whose uncle Don Pio de Tristan de Moscoso, was the aforementioned Viceroy. Flora Tristan was much of a *bas-bleu,*** an advanced woman of those days. She wrote sentimental novels of incredible length, delved deeply into the study of economics and sociology, and lived on very bad terms with her husband, who, however, as Victor Sagalen delightfully expresses it, "loved her with such devotion, that, after three years of wedded bliss and eighteen of separation, he gave her the greatest proof of devotion that a husband can give his wife, and attempted to kill her. But she went on writing novels without pity on either her readers or her husband, who was condemned to forced labour for twenty years."

Gauguin was born in Paris in 1848. A short time after the political events of that year, which had been somewhat disastrous to his fortunes, his father, Clovis Gauguin, a Parisian journalist, decided to leave France with his family for Peru, where he hoped to found a newspaper of his own. But he died at the Straits of Magellan, and the mother, with her three-year-old son, went on alone. They remained four years at Lima with the Viceroy, whose death at one hundred and thirteen years of age, decided their return. It was a happy time, shot through with memories of that rather troubling world, where each family of station kept its own madman chained on one of the flat terraced roofs, and where, when the earthquakes jangled the ancestral portraits upon the wall, it seemed to the little boy that their eyes were waking to an unnatural, gleaming life.

On their return to France the family squandered a large fortune left by Don Pio, and, being now in reduced circumstances, settled at Orleans where Gauguin was placed in a religious school. He remained there until, at the age of seventeen, it was decided that he should enter the French Merchant Marine. He detested the life and often afterwards spoke of it bitterly. His mother died in 1871 while he was in the Indies, and at twenty-one years of age he left the Service. Through influential friends he obtained a position in the firm of M. Bertin, a stockbroker in the Rue Lafitte, where he became very successful, sometimes making annually thirty or forty thousand francs. He remained there eleven years, a steady, clever manipulator, conforming to the bourgeois standards about him. In 1873 he married

*"His work is sickening in its coarseness and brutishness."

**Intellectual or literary woman (bluestocking).

Mlle. Sophie Gad, a young Danish girl, and had by her five children. And so it seemed that he was destined to remain, an industrious, quite commonplace and respectable citizen.

Then came a change. The exact way of it is not known, but in the home of Monsieur Arosa, an old family friend, was a large collection of pictures of the modern school. Was it these that first turned the eyes of the successful stockbroker from the wide, easy path of his assured existence to those tangled and mysterious bypaths of art? However it was, on Sundays and holidays he commenced painting. In the evening, escaping from the doors of his immaculate home, he wandered into the Quartier of the artists or climbed the steep streets of Montmartre to the little smoky cafés where the outlaw artists of the new school used to gather—that small group of painters who, having thrown off the shackles and conventions of the official salon, were winning their way to fame under the despised sobriquet of Impressionists. There he met Pissarro and Guillaumin and Monet and Degas. There he heard the tenets of the new painting, and, thrilling to the fascination of it all, he listened, and from time to time bought a few pictures.

Slowly his passion for art deepened. The stolen Sundays and holidays no longer sufficed, aggravating only his desire to paint; and within two or three years came his decision to give up everything, family, social connections, ease, all that had been precious to him, and to devote himself only to his art. But not until he was thirty-five was he able to say:

"From now on I shall paint every day."

He became the pupil of Pissarro and in 1880 he first exhibited with the Impressionists. This early work caused little comment, for as he was still a pupil, following in the steps of his master, and troubled, driven almost to despair by the gravity of the decision he was making, his work was not in reality his own. So matters went for a year or more, until forced at last to realize the unalterability of his decision, his wife consented to a separation. She took the children with her and returned to Denmark where, through her influential family connections, she supported herself in a fair degree of comfort by the translation of French novels into her native tongue.

Gauguin remained in Paris, far now from his luxurious quarters in the Rue Lafitte, removed as into a strange city and a strange world, in the midst of this glittering Paris he had known so well. He lived a hand-to-mouth existence in humble quarters, painting when he could with a sort of savage ferocity, but when all sources of revenue were exhausted, when there was not a sou in his pocket for bread or paint, he took on curious jobs, such as the pasting up of advertisements in the Gare du Nord. But always and in spite of everything he painted. Artists were now his only companions, and at night no matter to what straits he had been reduced during the day, they met at the Côte d'Or or at the Café Guerbois for long hours of talk before the little glasses of absinthe.

In 1886, obscurely drawn from the beginning by his longing for the tropics no less than by his growing distaste for Paris, he went to Martinique, accompanied by a young painter, Charles Lavalle. They returned after a year, driven back by the viciousness of the climate. Gauguin had, however, done a great amount of work, and, what was of far more importance, he brought back a new artistic vision. He broke away entirely from the Impressionists, from all his models of the olden time, and, forsaking Paris, went to Pont-Aven in Brittany.

The immense distance which separated the earlier work of Gauguin from that of the so-called Pouldu period cannot be well understood without at least a fleeting inquiry into the theory and technical formulas of the Impressionistic school.

"These men," I quote from the French critic, Charles Morice, "revived that art which the academies had killed. They placed themselves beyond the law, rejecting the false official teachings and cold formulas deduced by professors from the work of the Renaissance. They had discovered Light and, intoxicated by it, they worked in a dazzled enthusiasm, using the hand as a mere intermediary. It was just as if the coloured ray shone from their eyes upon the canvas, and they worked untroubled by the shapes which the ray made brilliant, without intervention either of feeling or of thought, happy slaves and idolators of the sun. In this system, which curtails as far as is humanly possible the personality and will of the individual, the artist must renounce, on principle, composition, decoration, expression, style. He is no more than the sensorial intermediary between man and nature—and not even an intermediary; for it is nature itself which is reflected in the painted work . . . in truth the work is not a picture, it is really only an impression. And the word invented by the Boulevard to express the formula, *impressionniste*, is perfectly correct, despite the protests it has caused. The impressionistic painters halt the sun to eternalise one of its instants, but they never mix their souls with its light."

Another analysis of their theory is one given by M. Théodore Duret in his volume *Les Peintres Impressionnistes*.

"The first Impressionists—the painters of 1874—followed two fundamental rules; first, the use of clear tones in juxtaposition, so repudiating the traditional practice of opposing light and shade; secondly, painting with the eyes directly upon the subject, so as to render it with absolute truth. From Manet they took the idea, though greatly extending and diversifying it, of using clear colours; and the determination of reproducing only what they saw had its birth in Courbet's aphorism, one must paint only what the eyes actually perceive."

Such was their dogma, and the fact that in reality the greatest among them did not actually realise this ideal, that in spite of themselves, as it were, their personality impinged upon their work and gave to it a distinctive and unique charm, did not, to Gauguin at least, make it the more valuable. To his mind their masterpieces were only "happy accidents"—the splendid fruit of the

genius of a few great men—rather than the inevitable products of a new view of art, capable of stimulating the creative powers of the newer and younger artists.

He himself wrote: "The Impressionists study colour exclusively, but without freedom, always shackled by the need of probability. For them the ideal landscape, created from many different entities, does not exist. They look and perceive harmoniously, but without aim. Their edifice rests upon no solid base and ignores the nature of the sensation perceived by means of colour. They heed only the eye and neglect the mysterious centres of thought, so falling into merely scientific reasoning. When they speak of their art, what is it? A purely superficial thing, full of affectations and only material. In it thought does not exist."

Thus it was that Gauguin, after serving his technical apprenticeship among the Impressionists, cast off their teachings and, immediately upon his return from Martinique, took up his abode at Pont-Aven in Brittany. There, surrounded by a few young artists, he first formulated those principles of Synthesis and Symbol which have since become so famous, and which served so well to lead him to that newer and profounder art.

Yet Gauguin detested formulas. He wished to paint as the mood seized him, in absolute freedom from all artificial constraint. But in that sombre Brittany to which he had withdrawn, the new spirit that had come to him in Martinique, the return to the simplicity and directness of a less sophisticated age, to an almost mystical and primitive envisioning of nature, asserted itself. The artist, influenced perhaps by the tragic grandeur of that desolate land, and oppressed by the sadness of his own heart, turned to the painting of those symbolic canvases which form so strange a contrast to the luxuriant and lush splendour of his Tahitian scenes.

The exact theory of this new art is rather vague, and it was only in the most general way, and as if involuntarily, that Gauguin ever made it explicit, though his pupils, or rather his companions, have not hesitated to attribute to him many of their own definitions.

"You know," Gauguin wrote in one of his Tahitian letters, "that though others have honoured me by attributing a system to me, I have never had one, and could not condemn myself to it if I had. To paint as I please, bright today, dark tomorrow. The artist must be free or he is not an artist.

" 'But you have a technique?' they say.

"No, I have not, or rather I have one, but it is a vagabond sort of thing, and very elastic. It is a technique that changes constantly, according to the mood I am in, and I use it to express my thought, without bothering as to whether it truthfully expresses exterior nature.

" 'Is there a recipe for the making of beautiful things?'

"And the answer I have repeated so often: 'I am capricious.' "

But his practice, if not his admitted theory, he expressed in a few words:

"The right to dare everything in art in the name of the spirit. The absolute and legitimate domination of thought upon nature, and the need of the artist to express thought by artistic means, equivalent to nature's own."

During the years which followed the trip to Martinique, Gauguin was sometimes in Paris, sometimes in Brittany, and was for a short time at Arles with van Gogh. That experiment in "artistic communism," with its tragic denouement, came as a crushing blow, and was undoubtedly instrumental in augmenting his already profound hatred and distrust of European civilisation. And again his thoughts turned with longing towards the distant tropics, far from the exasperations of *"ce sale Europe."**

In 1891, with the help of his artistic and literary friends, Gauguin held a sale of his belongings at the Hôtel Drouot. Among them were many of his own pictures as well as various *objets d'art* and some of the paintings he had bought from the Impressionists in early days. In this way, he realised nine thousand eight hundred and sixty francs. Octave Mirbeau, the novelist and art critic, wrote a glowing appreciation of Gauguin and his art for *L'Echo de Paris*. And the article, later reproduced in the catalogue for the sale, attracted a great crowd. So at last in April, though with far too limited means, Gauguin was able to leave on his first Tahitian trip.

The letters which follow extend over a period of twelve years, the last being written only a few weeks before his death. In much of this correspondence there is, for the casual reader perhaps, a lack of the picturesque and sensational that may seem disappointing. It is rather for those interested in the life and psychology of a great artist, and in those often bleak material facts which account for and explain the psychology, that these letters may have the strongest appeal.

*"This filthy Europe."

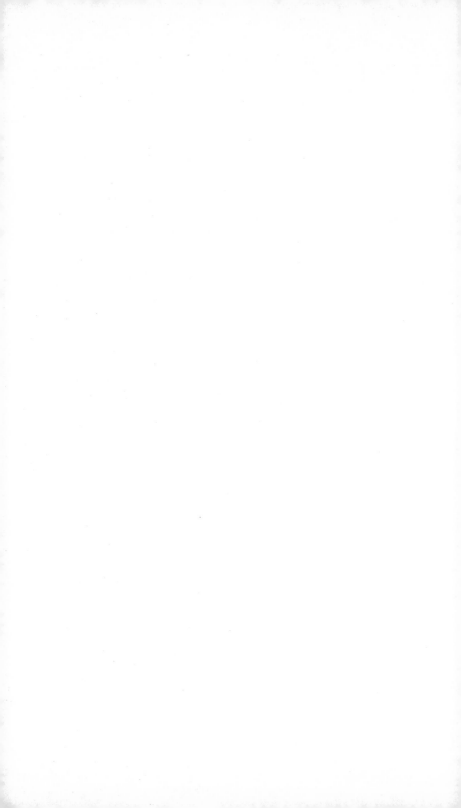

THE LETTERS OF PAUL GAUGUIN
TO GEORGES DANIEL DE MONFREID

This first letter, though perhaps of no especial importance, as it was written on board ship only a few days after leaving France, is of a certain interest; for it is here that the name of Juliette appears, of whom there is so much mention in many of the succeeding letters. She seems to have been a much-loved mistress, whose unhappy position troubled Gauguin through these first Tahitian years, and whose charms he did not forget even while enjoying the more exotic favours of the Maori beauties. But as to who she really was or the details of her history, the letters throw little light, and after Gauguin's return to France all mention of her ends.

I

2nd April, 1891.

My dear Daniel:
 Just imagine, my trip via Nouméa may last still longer and cost another 500 francs, for they say that connections are very irregular. It may be from three to five months. So if any of our friends want to go there warn them to take the direct route—New York, San Francisco . . .
 I was wrong to go second class, third is almost as good and it would have saved me 500 francs. Just another word so that my letter will not be late. Kiss Juliette for me with all your heart.
 Cordially to all the artist friends,
 P. G.

En route for Mahé.

II

(Tahiti) 7th November, 1891.

My dear Daniel:

I am beginning to think that everyone in Paris is forgetting me, as I get no news and here I live very much alone, speaking only the little Tahitian that I know. Yes, my dear fellow, not a word of French.

Poor Juliette with a child, and now I can't help her. I am not surprised that the little one is feeling ill. It happened in spite of everything; God knows the conditions under which I did it.

However. . . .

You ask what I am doing. It's rather difficult to say, for I myself hardly know what it amounts to.

Sometimes it seems to me to be good and yet there is something horrible about it. As yet I have done nothing striking. I am content to dig into myself, not into nature, and to learn a little drawing; that's the important thing. And then I am getting together subjects to paint in Paris—if this tells anything, so much the better; I cannot say more without inventing stories and filling you with illusions that you would lose on my return. . . .

I see by your letter that you, too, are having troubles. The earth will not change its ways, and other things disagreeable to man. Why have men invented such troubles, as if nature had not done them enough harm in giving them bodily ills?

They've invented a phrase in Tahiti—*No Atou*—it is our "I should worry," and use it here with perfect naturalness and ease. You do not know how used to it I have grown. I repeat it often and I understand it.

Well, a warm handclasp to you, and best wishes to your sweetheart and to our friends.

This scrap of paper is for Juliette.

Tout à vous
Paul Gauguin

* * *

Despite the almost infinite readjustment of all values, material as well as spiritual, which was made necessary by Gauguin's determination on that complete discard of European civilisation, on that "turning native" to which he devoted himself with such ardour, he soon commenced painting in earnest. For in the following letter, written only six months after leaving France, he speaks of having completed the now famous *Ia Orana Maria* (Mary, I salute you) whose appearance recently in one of the New York galleries created such a sensation.

And here, too, comes the first hint of that mysterious illness which darkened his whole Polynesian life. The exact nature of this malady is an open question which possibly may never be fully settled. But that it was not

leprosy, as has been hinted from time to time, was established through the statements of Dr. Chassagnol, the chief medical officer of Tahiti, who cared for Gauguin for many months while he was in the hospital in Papeete.

<div align="center">III</div>

<div align="right">11th March, 1892.</div>

My dear Daniel:

 I received your letter with more pleasure than you could believe. Letters are a precious fruit to me; I've had so few since coming here. I still have had nothing from N—— . . . and it worries me; not only for the money which I counted on having, but that I don't know what I may depend on. You are right, my friend, I am a strong man who can bend fate to my will. I can tell you that to do what I have done for five years is a great achievement! To say nothing of my struggle as a painter—and that was nothing small—but of my struggle to live, and with never a chance!

 Sometimes I wonder that something doesn't break, I hear so much cracking. Well, we must always go on; there is ever the great remedy at the end.

 I am going to let you into my secret a bit. There is a great deal of logic in it and I act methodically. From the outset I knew that it would be a day-to-day existence; so, naturally, I've had to accustom my temperament to that. Instead of wasting my strength working and worrying about tomorrow, I put everything into the present, like a fighter who does not move until the moment of the struggle. When I go to bed at night I say to myself—one more day gained, tomorrow I may be dead.

 In my work of painting it is the same thing. I only think of the present. But the methodical way is to arrange matters so that things follow smoothly, and not do on the 5th what should be done on the 20th. The madrepores do the same—and at the end quite a lot of ground is covered. If only people did not spend so much time in useless and unrelated work! One stitch a day—that's the great point. But enough of this.

 I have been seriously ill. Imagine—spitting up blood, quarter of a litre a day. It was impossible to stop it; mustard plasters on the legs, cupping of the breast, nothing helped. The hospital doctor was pretty much worried and thought I was done for. The chest was intact, but my heart was playing me tricks. And it has had so many shocks that there's nothing very astonishing about that. Once the vomiting of blood was stopped, I followed a digitalis treatment, and now I am better and see no signs of a relapse. Still—I must be careful.

 My life is now that of a savage: my body naked except for the essential thing the women do not like to see—so they say. I am working all the time,

but up till now only studies, or rather documents, are piling up. If they are not useful to me they will be so to others. However, I have done one picture: An angel with yellow wings points out a Tahitian Mary and Jesus to two native women—nudes clothed with a pareo, a sort of flowered cotton cloth, that can be attached as one likes to the waist. The lower slopes of the mountain are very dark with blossoming trees. The road dark violet, the foreground emerald green. Banana trees to the left—I am quite pleased with it.

You ask for an exchange of canvases? Certainly; don't worry about that. You know whether I am stingy or haggle over such matters. What's this you say about Z——? . . . He must be ill, I think—so he's been complaining of my character to my wife!

God knows whether I really have such a bad character; you have been able to judge it for yourself.

I have only enough space left to say goodbye to you and to my friends.

<div align="right">Cordially,
P. Gauguin.</div>

<div align="center">* * *</div>

Gauguin's amusing adventure with the pirate, related here with such gusto and delight, gives us an all-too-brief glimpse of the lighter and more picturesque side of his Tahitian life. In these letters much has been left unsaid, owing no doubt to those pressing exigencies of material life, to lighten which *"Mon cher Daniel"* seems to have been his sole mainstay and support—the one ever-faithful friend on whom he could depend. It did not take long for his relations with the whites in Papeete to become strained to the breaking point. He despised them utterly, and they in turn were scandalised by that "turning native" in which he took such vast delight. Some thought him a spy, others believed him mad—or worse. For in the tropics the white who mingles openly with the Maori or Malay is no less than a social pariah, to be shunned and ostracised, as a man betraying the alleged code of the superior race.

But to Gauguin, the French-Peruvian, who hated and feared the civilisation from which he had sprung, the white man's code, with its hypocrisy and secret corruption, was viler far than the simple and quite childlike unmorality of the natives with whom he lived. This was, at all events, Gauguin's viewpoint. And to understand him and his art, we, too, must accept, or at any rate try to comprehend, the vastness of the revolt which flung him here on this obscure island, an outcast; and living, as Huneker once put it, "like a divine beachcomber," warring both in life and art with the civilisation he had left behind.

IV

June, 1892.

My dear Daniel:

I was so glad to receive your letter, for otherwise my mailbag would have been empty. No news from Europe. A queer thing happened yesterday. I was in town, which is about forty kilometres from my place, to see the Governor and to try to get my passage back to France. I had about forty-five francs in my pocket. I suppose you will think that I'm not cautious to let everything go that way, but I am like that. I keep up until the last moment, and then I am hoping each month for a few sous from France. Sister Ann, don't you see anything coming? Nothing! I say to myself that it would be stupid to leave and perhaps to pass a bank note on the way. So I am compelled now to lie to until the very last. And I rage like a furious fool. Just at the entrance to the Government House I met a captain who sails about the islands in his own brig and who is believed to be a pirate. I made his acquaintance a couple of months ago.

"What the devil are you going to do in this galley?" he asked me.

"*Ma foi,* * I'm going to do the most disagreeable thing possible. I'm going to beg my passage home from the Governor: my ship is adrift and I'm on the rocks."

Then the rascal slipped four hundred francs into my hand. "You give me a picture and we'll call it square."

So I did not go to the Governor, and here I am hoping once more for money from France.

Possibly I shall do a portrait of the pirate's wife and then he will give me 1,300 francs more. But for that we must exercise great diplomacy with the lady, who is not always easy to manage, so he says. Then I can raise my topgallant sail and have ten months of peaceful work. It's only to me that such things happen.

I have been working hard all this time and up till now have covered forty metres of good canvas with Lefranc and Co.'s colours. I think I shall be able to pull through, and really it would have been a shame to leave. I'm just finishing a sort of carved Kanaka's head lying against a white cushion, in a palace I invented, and surrounded by women, also of my own imagination. I think it is a pretty bit of painting. Yet it's not altogether mine, for I stole the idea from a pine plank. You must not say anything about it, for one does one's best, and when marble or wood insist on tracing a head for you, it is very tempting to steal.

*My word, or my honour.

And here you are with your foot in the stirrup again. You are right. You must regain your strength, in spite of the indifference of your family and other difficulties. To be hard as a stone means to be strong as a stone. I must laugh at your advice about my health—not to use too much alcohol or adulterated wine. I can assure you that you are mistaken. It's clear water every day. When you see me again you will see Gauguin with the waist of a young girl. And I console myself with the thought that I must have been disgusting looking when I was getting so fat. . . .

Ah, yes; stained glass windows. That is a good craft to revive. Really I believe it would do you no harm, especially if it gives you a little independence.

My letter may seem a little disjointed, but I'm still excited about my adventure yesterday with the pirate. I roar with laughter when I think of it. No—it's only to me that such things happen. It has been that way my whole life; I stand at the edge of the abyss, yet I do not fall in. When van Gogh went insane I was just about done for. Well, I got over it. It forced me to exert myself. All the same my life has been a queer mix-up.

By waiting I gained a few days, and I am going to work.

Greetings and handshakes to all our friends.

<div align="right">Cordially,
Paul Gauguin</div>

<div align="center">* * *</div>

The odd mix-ups in Gauguin's life, so fleetingly referred to here, were indeed numerous, and it was often with a perverse sort of pride that their incidents lingered in his memory. In Paris it was said that he possessed "an evil eye" and he himself once admitted it. "Many men with whom I have associated have gone mad," he said. But from among all these, the van Gogh incident, known more generally as *"l'incident de l'oreille coupée,"* * stands out, not only through the fantastic horror of the events themselves, but through the later fame of the protagonists.

Gauguin's friendship with van Gogh was of long standing, and after his return from Martinique, van Gogh, then living at Arles, insisted on his joining him there. Hesitantly, as if against his own better judgment, Gauguin consented. Already van Gogh enjoyed a great reputation among the younger men, and, relieved from the pressure of pecuniary wants through the understanding generosity of a brother, he had retired to the quaint old town of Arles, where he worked in almost monastic seclusion. The two friends were dissimilar in temperament, mode of life, and even in their artistic and literary tastes; from the first a certain strain and tension made itself felt.

*"The incident of the severed ear."

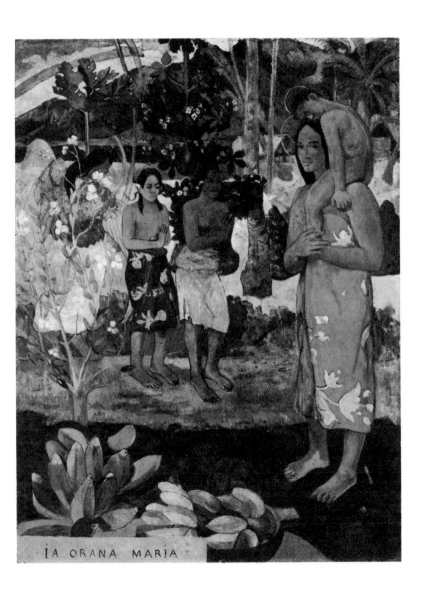

Ia Orana Maria, 1891

Van Gogh grew moody and irritable. One day, as if a vague presentiment of the future had come over him, he turned to Gauguin, who was working upon his portrait.

"Yes, the likeness is there," he said slowly, "it is I—after I have gone mad."

What follows is Gauguin's own story:

"That same evening we went to a café and van Gogh took a mild absinthe. Suddenly he threw the glass with its contents at my head. I dodged it, and, taking him by the arm, I led him home, where he threw himself on the bed and slept till morning.

"On waking he said, 'My dear Gauguin, I have a vague memory of having offended you last evening.'

" 'I forgive you with all my heart, but last night's scene might be repeated, and if I were hit I might lose control of myself and choke you. So allow me to write to your brother of my return.'

"My God—what a day!

"I gulped down dinner that night and, wishing to be alone, left the house.

"When I had almost passed through the Place Victor Hugo, I heard quick, sharp little steps behind me that were very familiar. I turned just as Vincent was starting at me with an open razor in his hand. My gaze must have been very powerful, for he stopped, lowered his head, and then started running towards the house.

"Was I cowardly then, not to have disarmed him and to have attempted to soothe him? I have often searched my own conscience, but I do not reproach myself. Let whoever wishes throw the first stone.

"I went at once to a good hotel, where, after enquiring as to the time, I took a room and went to bed. I was so nervous that I did not fall asleep until nearly three, and I did not waken till nearly half-past seven. When I came out into the square, I saw that a great crowd had gathered. There were policemen near our house, and a little fellow in a Derby hat, who was the Police Inspector.

"This is what had happened:

"Van Gogh returned home and shaved off one ear smoothly from his head. It must have taken him some time to stop the bleeding, for next day a number of wet towels were found strewn about the floor of the two lower rooms. And his blood had soiled the rooms and the little staircase which led to our bedroom. As soon as he was able, he did up his head tightly in a Basque cap and left the house. He went straight to a house of shady repute and handed his ear, which had been well washed, to the porter. 'Here,' he said, 'is a present from me.' Then he hurried home, went to bed and fell asleep. He was careful to close the blinds and to leave a lighted lamp near the window.

"Ten minutes later the street, given over to the *'filles de joie,'* was in a tumult, and they were all chattering about what had happened.

"I was far from suspecting anything, however, when I came to our house. The man in the Derby hat said to me severely:

" 'And what, sir, have you done to your comrade?'

" 'I don't know.'

" 'But yes, you must know it—he is dead.'

"I could not wish such a moment on anyone. It was a long while before I could collect my thoughts and understand the beating of my heart.

"I stammered, 'Sir, let us go upstairs and I will explain.'

"Vincent was lying in the bed, completely covered by blankets. He seemed inanimate. I touched the body very gently and its warmth reassured me. He was still alive. This certainty seemed to bring back all my energy and intelligence. I spoke softly to the Police Inspector.

" 'Sir, I beg you to awaken this man with the greatest care, and if he asks for me say that I have returned to Paris. The sight of me might be fatal to him.'

"After he had waked, Vincent asked for his comrade, then for his pipe and tobacco, and ended by even demanding his money box which was downstairs. Doubtless a suspicion! It did not trouble me, for I am proof against suffering.

"Everyone knows what followed and it would be useless to speak of it, were it not for his terrible suffering. Though in an asylum, he came to himself from time to time and he realised what had happened, but in his lucid moments went on painting those admirable pictures we know so well.

"The last letter I had from him was from Antwerp. He said that he had hoped to be well enough to join me in Brittany, but that now he realised the impossibility of a cure. 'Dear Master' (it was the only time he ever used that word), 'it is better, after having known you and wronged you, that I die in a clear mind rather than in a degraded state.'

"He shot himself in the stomach with a pistol and died a few hours later, lying in bed, smoking a pipe, his mind clear as ever, loving his art and hating no one."

So ended the van Gogh incident, and can one wonder at the haunting, sombre memory from which Gauguin was never freed?

V

5th November, 1892.

My dear Daniel:

Quick, quick, I'm replying to your letter. I received the 300 francs you sent. Well, we shall see! For the present I shall be able to lie to awhile, but unless I can get a sum large enough to make me absolutely safe, I shall not go to the Marquesas, and I should love to go there before I return. My health is not good. I am not ill exactly (the climate is wonderful), but all these worries over money are bad for me, and I've aged in an astonishing fashion, all of a sudden. I suppose it's because, to keep my affairs in any sort of order

and to avoid running into debt, I hardly eat. Only a little bread and tea. I've grown very thin on it, am losing my strength and ruining my stomach. If I went to hunt bananas in the mountains, or to fish, I could not work, and, besides, would probably have a sunstroke.

Oh, how much misery on account of this accursed money!

Many thanks to friend Maillol and greetings to all the comrades.

<div style="text-align: right;">Always yours,
Paul Gauguin</div>

I've had a letter from Sérusier with all sorts of news about the new crowd of painters. I can't find that drawing for Mirbeau (must have used it to wrap something in). I will send you another drawing for him. Ask Bottin for his address, or Joyant. You must remember me to him. He might be useful to me on my return.

<div style="text-align: center;">* * *</div>

Even on this first Tahitian trip, as the following letters show, Gauguin's financial difficulties began. His greatest trouble seems to have arisen from the fact that, instead of leaving France with his affairs clearly settled, he trusted to the promises of various creditors who promptly forgot or ignored their obligations as soon as he was gone.

<div style="text-align: center;">VI</div>

<div style="text-align: right;">8th December, 1892.</div>

My dear Daniel:

This month no letter from you, or, for that matter, from anyone. I am at present in a state of apprehension and after a piece of good news. Just imagine, last month I had received notice that I could leave whenever I wished, but that the cost of the voyage would be charged to the capital, the Colony having insufficient funds. So here I am reassured. I decide to leave in the month of February and, while waiting, I begin work. I bring forth four good canvases. I go to Papeete, I speak with the Governor. He says: "You cannot leave unless the ministry gives us a formal order." Even if the reply is favourable, I shall not get it before the end of April.

At the same time as my letter you will receive, I think, a package of canvases. An artillery officer will take charge of them and will put them on the train. Freight on delivery. My apologies; I cannot do otherwise. I am anxious about the transit and fear that some repairs will be necessary. Wash

them carefully and take care not to remove the paint and the preparation; and varnish them. Write to my wife and find out when they must be sent for the Exhibition. Add also *Vahine No Te Tiare* (The Woman with the Flower). Ask her if the Exhibition pays the carriage, in which case you will have them sent on stretchers. If not, on rollers. Send her the exact measures, so that she can have frames made. In any case, I am writing her. Here is the list of titles:

Parau Parau—Conversation or the gossips.
Eaha Oe Feii—What, you are jealous?
Manao Tupapaü—Think of the Ghost, or, The Spirits of the Dead are Watching.
Parahi te Maraè—Behold the Maraè! (Temple of Prayers and Human Sacrifices).
Be good enough to attach the following titles to those which have none:
Woman in Chemise—*Te Faaturuma*.
Landscape with Large Tree—*Te Raau Rahi*.
House with Horse—*Te Fare Maori*.
Two Women and a Dog—*I Raro te Oviri*.

I have chosen for this Exhibition something for every taste,—figure, landscape, nude. Provided these all arrive in good condition, I make a suggestion: take the inside measurement, so as to be able to stretch the canvas well. This is the way to stretch it: you slightly moisten the back of the canvas and stretch it. Put the nails into the same holes, or else you will rip the canvas. If you send the canvases not stretched, write these directions to my wife: Madame Gauguin, 57 Vimmelskaftet, Copenhagen K.

<div align="right">Cordially yours
P. Gauguin</div>

P. S. If by some extraordinary chance purchasers should be found immediately, I *will not* let them go for less than 600 francs; according to the importance of the canvas, set the prices, 600, 700, 800, etc. As for the one entitled *Manao Tupapaü*, I wish to reserve that for a later sale. *Or else, 2,000 francs*. When I arrive I shall see. Anyhow, I have written this same thing to my wife. This picture is for me (excellent). Here is the genesis (for you only). General Harmony. Dark dull violet, dark blue and chrome 1. The draperies are chrome 2, because this colour *suggests* night, without explaining it, however, and furthermore serves as a happy medium between the yellow orange and the green, completing the harmony. These flowers are also like phosphorescences in the night (in her thoughts). The Kanakas believe that the phosphorous lights seen at night are the souls of the dead.

In short, it is a fine bit of painting, although it is not according to nature.

VII

End of December, 1892.

My dear Daniel:

I have little to tell you. Am in utter despair. I have fifty francs left and there is nothing on the horizon. Even should the Minister reply favourably to my letter, I shan't know until the end of March at the earliest. Until then what shall I do? I shall end by losing my head completely, and it does my health no good. Though I am not exactly ill, I feel that all my rigging, formerly so strong, is going to break. And it doesn't make one any younger. When I really stop to think things out, I realize that on my return I must give up my painting, for I cannot make a living with it. I left Paris after a victory, small enough, but still a victory. In eighteen months I have not made a cent with my painting, which means that I have sold less than ever before. The conclusion is easy to draw. And as I can hope for no large inheritance, with what can I buy food, or even colours? It is true that I shall bring back some canvases! And my work is improving, which means that it is less saleable than before.

If van Gogh had not died . . . then, perhaps. But while waiting I am in a dreadful hole.

I am just finishing three canvases. I think they are among my best, and as it will be the first of January in a few days I've dated one, the best, 1893.

As something rather unusual I've given it a French title—*Pastorales Tahitiennes*, for I cannot find a corresponding title in the Kanaka tongue. I do not know why, but even when laying pure Veronese green on the same sort of vermilion, I still have the impression of its being like an old Dutch painting—or an old tapestry. How do you account for it? But as far as that goes all my canvases seem drab. Perhaps it is because now that I no longer have my earlier work to look at, or any pictures of the Beaux Arts school, I'm not able to make a fair comparison. What a memory! I am forgetting everything. Am using too much tobacco perhaps. On my return I must see about it.

In what condition will you receive the canvases that I sent? I tremble for them. In your letter you say that on account of the death of your mother-in-law you are living with your family again. I did not understand whether you were getting a divorce, or simply had left the conjugal roof by mutual consent. Is the door open or closed? Or only half-closed? This last situation I should think bad. Clarity—it is the most important thing. As you know I cannot congratulate you on your new paternal state; you can say the same thing to me; but for me, who am hardly ever there, and am so loosely bound, it is not quite the same thing; it is not so serious.

It seems that my new offspring is doing marvellously well. Juliette has written me, giving her new address, and all the news about the baby. If by some extraordinary chance you have some money for me, keep it until April. I hope to leave by that time. Anyway you will hear through Sérusier,

who should already have taken the steps which I indicated in my earlier letter.

I press your hand.

Tout à vous
Paul Gauguin

VIII

February 11, 1893.

My dear Daniel:

Your letter this month finds me in despair. I have no money and it will be at least three months before I can hope to leave, even supposing the Minister does send me home. If he does not, I really don't know how I shall get out of the muddle.

I've had a letter from Joyant, who says: "You can't imagine how the spirit has changed and to what extent your crowd has arrived." Besides, he sent me my account, in which I see that 853 francs were turned over to N—— on the 23rd of May, '91—that is to say, almost two years ago. Which means that N—— has swiped 1,353 francs from me, which would have saved my life. Joyant sold about 1000 francs' worth of paintings for me, deducting the commissions just after my departure. I admit that to learn of this theft has broken me all up—for it *is* a theft.

My wife has again sold paintings to the tune of 850 francs. But she is hard up, so excuses herself for not sending me anything, and what can I say?

It seems that my success is growing in the North. A London artist told her that I should absolutely exhibit in England. I must return to go into all this. My God, how I rage! It is really anger that keeps me going. After this letter don't write any more, and if you have money to send, keep it for me carefully. You say that Z—— has written to my wife? What for? He would have done better, knowing the position I am in, to have sent me my passage. I should have been glad to pay twenty per cent for it on my return, and at that I should have been ahead. But there are people who never know how to be useful in time, nor how to do a good stroke of business. . . .

And poor Aurier is dead. Truly we are in bad luck. Van Gogh and then Aurier, the only critic who has ever really understood us and who might have been useful some day.

Best of wishes to everyone.

Cordially
Paul Gauguin

* * *

Above the never-ending monetary difficulties, which fill many of the letters with a note of gloom, rises here a brighter and more hopeful light.

Gauguin's reputation, if not his pocketbook, seems to be growing. In fact, among the connoisseurs he had never been ignored. The nude study which is mentioned in the following letter, a product of his student days and done in a mood of starkest realism, was given high praise by Huysmans, who wrote of it, "I do not fear to assert that, among contemporary painters who have studied the nude, none have done anything more vehemently realistic."

And it is not uninteresting to note by way of contrast, and also more clearly to understand the vastness of the change which had come over Gauguin's spirit since those first debuts in the realistic and impressionistic art of the day, an article by Aurier, the critic whose death was spoken of in the preceding letter.

It was of that symbolistic masterpiece of the Bretagne period, *La Vision après le Sermon*, that Aurier wrote:

"Far, very far away on a mysterious little hilltop, whose soil is of shining vermilion, is the biblical struggle of Jacob and the Angel. As these legendary giants, whose forms are shrunk to the size of pigmies by distance, wage their great battle, some women watch, naïvely interested, doubtless understanding none too well just what is happening there, on the fabulous encrimsoned hilltop. And from the spreading sails of their white coifs that reach out like the wings of a seagull, and from the oddness of their fichus, and from the fashion of their dress, one guesses them to be Bretons.

"Their respectful attitudes and strained faces are those of simple folk who listen to fantastic and extraordinary stories told by some incontestable and revered tongue. One might think them to be in a church and that a vague odour of incense and of prayer is floating there above the white wings of their coifs, and that the respected voice of an old priest rumbles above their heads. Yes, without doubt, it is in a church, the poor church of some little Breton town. . . .

"But where, then, are the mouldy green pillars? Where the white walls with the small coloured lithograph of the *Chemin de la Croix*?* Where is the pinewood pulpit? Where the old Curé who is preaching and whose grumbling voice is certainly audible? Where all this?

"And why, far, so very far away, rises the fabulous hilltop whose soil is of shining vermilion? Ah—it is because the mouldy, green pillars and the whitish walls and the little chromolithograph of the *Chemin de la Croix* have been gone for many minutes; they are nonexistent in the eyes and souls of these good Breton peasants . . . the material things surrounding them have drifted away like smoke, have utterly disappeared. He himself, the evoker, is effaced, and now it is only his voice that holds the devoted and naïve attention of these white-coiffed peasants; and it is his voice, this rural fantasy, which rises there, far, so very far away."

*Way of the Cross.

IX

March 31, 1893.

My dear Daniel:

I received your July (?) letter, and I am writing you because, as you see, I'm still here. Yes, my friend, I'm continuing to lie to with rage and obstinacy, in spite of the muddle I am in. . . .

Thank God you received the study I sent—I feared that the fellow might have swindled me. This study is only a step to better things. That you thought it superb, so much the better. You know it is by me; not by C——. I have about fifty canvases that will perhaps make you gasp, for many of them are better than this study. Just now I'm carving some barbaric bibelots from tree trunks. I have a bit of ironwood to bring back that has just about put my fingers out of commission, but I am pleased with it.

I had a letter from my wife, who sold four canvases immediately upon her arrival in Copenhagen—one, which was insignificant, a little Breton head, brought 1,500 francs—and hopes to sell the rest soon. There is my money, you will say. But the poor woman is hard up. It doesn't matter, and things are coming my way in Denmark. They are going to hold an exclusive exposition there next spring and want me to send canvases from here. I can't do it, unfortunately. It would cost too much, and I have no money for shipping expenses.

Yes, there are many fools in Denmark who believe in the newspapers, so now they are beginning to think that I have talent. As for that, a Danish painter blew in nine hundred francs in becoming the possessor of the study I did of a nude woman in '76 (the one Huysmans spoke of). In all it came to more than fifteen hundred francs. Things are going well there. Snore, that's the password. I received two photographs in this mail done by a friend of Sérusier's, of my Christ on the Mount of Olives and of the woodcarving. They are to appear in the the the *Revue Contemporaine*, with an article by Aurier on the Symbolists. Have you heard anything about it?

I shall soon be a father again in Oceanica. Good Heavens, I seem to sow everywhere! But here it does no harm, for children are welcome and are spoken for in advance by all the relatives. It's a struggle as to who should be the mother and father nurses. For you know that in Tahiti a child is the most beautiful present one can give. So I do not worry as to its fate.

I see with pleasure that you are again on the path towards the Beaux Arts. But you must work and not lose any time. Stay firmly in your own path, and dare. Be mad two hours a day, and leave wisdom to Bouguereau.

E nei manao vau, tirara parau. Ia ora na.

This means that I've finished gossiping and that I greet you. I speak the Maori language pretty well now, and find it amusing.

So goodbye to you all.

<div align="right">

Tout à vous
Paul Gauguin

</div>

X

April–May (?), 1893.

My dear Daniel:

Seven hundred francs have come and how they will butter my spinach! If I had had them a month ago, I should have gone on to the Marquesas to finish the most interesting part of my work. But I am tired, and the boat for the Marquesas does not leave for a month and a half. Besides, I am expecting enough money next month to make my trip absolutely safe. Everything which keeps my head under water prevents me from coming to a decision.

I shall put on mourning for the Marquesas and will probably turn up in Paris one of these days.

What a funny fellow Z—— is! When sending me money, why not have written to me himself? What an age of human stupidity and vanity! That little creature is furious because I have "arrived" as a painter before him, and blames me for his slowness. Nevertheless, he has nothing to complain of. Born to be a simple workman, or concierge, or small shopkeeper, he could, without the slightest exertion, attain to the position of a "gentleman" and proprietor of a five-story house.

In painting he had a temperature below zero. After having been an admirer of Baudry and his crowd, he veered round from a spirit of opposition or for commercial reasons, as the Salon would not open its doors to him. Then, as you know, he preached the Holy War, wishing to follow and overtake me. But with my seven-league boots I am not easy to follow and, panting, he sat down by the wayside. If even then he had been obedient, but he would have his own way and wanted to be a pioneer, all the same. Thence all the disputes. He reproaches me with my integrity and fears for his liberty, etc. How contradictory! He wishes to walk alone and reproaches me for not having pushed him along. All this is sad and, above all, petty.

And now it's you who are discouraged. You are at the failure period. And sometimes it's an excellent thing. I can't judge from this distance with any certainty. I shall see on my return. But do not grow discouraged, and work.

Thanks for the paints. I still have a few left, and I will not need any more. For two months I haven't been actually working. I content myself by observing, reflecting, and taking notes. In my two years' stay, some months of which went for nothing, I have turned out sixty-six canvases of varying quality and some ultrabarbaric sculpture. It is enough for one lone man.

I think that just now I shall have more success in Denmark than in France. Unfortunately it is a small country and its resources are limited. The vein will soon be exhausted. Besides, today the young crowd, following in my footsteps, is beginning to make itself felt, and, as they have youth, hold most of the trump cards, and are perhaps more adroit, maybe I shall be snowed under on the road. But I expect to keep myself afloat by this new Tahitian work. It will be in such contrast to my Breton studies, and it will take them some time to follow me along this path. We shall see! That is

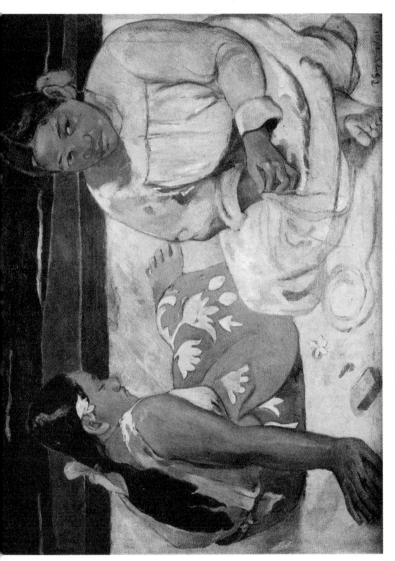

Tahitian Women (On the Beach), 1891

unless I stop painting, which, as I told you in my last letter, is not at all improbable.

Greetings to all our friends.

Tout à vous,
Paul Gauguin

You know that I have been troubled with insomnia and many of my children are in the same state. It is impossible to make them sleep of nights.

My wife sends me Emile's height—my eldest son—1 metre 96 at 18½. That's promising! So one will be able to say: Great Gauguin!

 * * *

The letter which follows is from Marseilles. As usual, Gauguin arrived there completely "broke," and, as usual, it was Daniel's aid he sought with naïve and complete assurance.

XI

Marseilles, 3rd August, 1893.

My dear Daniel:

I arrived today—Wednesday—at noon, with four francs in my pocket. You will think it strange, knowing that before I left I had gotten 1,000 francs. But after paying some debts, 650 francs were left; then no luck; had to wait over twenty-five days at Nouméa, and the hotel was expensive, what with shipping of packages, etc. . . . It was so bad on board ship that I had to pay extra for second-class accommodations. Good Lord, what a rotten trip! Three hundred troopers were there, and up forrard only about fifty square centimetres for the third-class passengers to move about in. Add to that very bad weather as far as Mahé. After that a terrible cold spell at Sydney, and frightful heat in the Red Sea—so bad that we had to throw three men overboard who died of the heat. Well—all's well that ends even pretty well—I'm here.

Immediately on arriving I sent off two telegrams, one to Goupil (Joyant), the other to you, asking for two hundred and fifty francs to help me out here at Marseilles. Just by chance I went to the General Delivery to inquire—a good idea, for your letter was there.

Would you please wire your concierge so that when I reach Paris on Friday I can have some place to stay? There I can get my bearings and see what I must do.

You don't say a word in your letter about the Copenhagen exposition. So there is no news, or bad news.

Best greetings to Annette. I pinch your claws.

Paul Gauguin

XII

Paris, September 4th, 1893.

My dear Daniel:

On my return I found your letter, and also one from my wife. I have just come from Orleans, where I had to go to attend my uncle's funeral. So I've had nothing but confusion since reaching Paris. The letter from my wife is not encouraging. My Tahitian work has had a moral success among the artists, but the result, as far as the vulgar public went, was—not one *centime*.

Fortunately, my uncle had the good sense to shuffle off, and his very small fortune will keep me afloat and will be a great help in getting ready for my exhibition. I do not know yet just how much my uncle left, but I count on about ten thousand francs. At the moment it will be my salvation.

Another thing I wanted to ask. When I told you to prepare for my return by looking for money, did you go to see Z——? I need to know this for my future relations with him when he returns. You understand. . . .

Cordially

Paul Gauguin

Juliette's address?

* * *

On the artist's arrival at Paris, he found things little to his liking. Most of his friends were away, and his situation might have been rather desperate had it not been for the timely demise of "*l'oncle* Isadore" at Orleans, who left him a small fortune of 13,000 francs. For the time it relieved him of his greatest worries, and he went on making feverish plans for the disastrous exhibition of 1893.

And at this time another misfortune befell him, which, though no mention is made of it in the letters, came as a hard and unexpected blow. Prior to his leaving Paris for Polynesia, Ary Renan, the director of the Beaux Arts, confided to Gauguin a so-called artistic mission. It was a more or less hollow and formal honour, yet it lent to him a certain weight and dignity among the colonial French. And, though gratuitous, Renan had promised him the official purchase of some of his paintings on his return. But on his return to Paris he found that Renan had been replaced by a new director, M. Roujon.

At their interview—I quote here from Gauguin's own account of the affair—Roujon said:

" 'I cannot encourage your art, which revolts me and which I do not understand. Your art is too revolutionary and it would cause a scandal in our Beaux Arts, of which I am the director.' "

"And again he observed, when we were discussing the promises of his predecessor. 'And have you them in writing?'

"So then it is a fact that the directors of the Beaux Arts are less honourable than even the common folk of the Parisian slums, and their word, even if given before witnesses, is good only with their signature.

"Well there was really nothing for me to do but to retire, which I did immediately, no richer than before."

XIII

Paris, 12th September, 1893.

My dear Daniel:

Since arriving I have been running about on different errands, most of them quite useless; no one is in Paris.

But anyway I have seen Durand-Ruel, who received me very kindly and who is again dealing with the Impressionists; for a while he was not selling their work. It seems that Pissarro and Guillaumin are selling well. He has promised to come and see my things when they are ready, and to exhibit them. So I shall hold to all this and, as it is not possible to do anything without a suitable studio, I have made a sacrifice and have rented 8 Rue de la Grande Chaumière (I even paid the rent in advance with money borrowed from the woman who runs the milk shop opposite).

I have been ransacking your studio, as I need some white shirts and haven't any in my trunk. I found nothing in the loft but a few canvases. Could you lend me your easel and a chair? If so, write your landlord that I can take some things from your place.

I did not understand your letter very well—You speak of remaining down there and of coming to Paris only occasionally.

I had a break with Bussod. Joyant has left him, disgusted with the whole crowd; there is nothing more of mine in the place. Let us hope that after my exhibition I will have some chance with Durand-Ruel.

Write me at length.

Paul Gauguin

* * *

Madame Caron, the kind-hearted *"crémière"* who made possible Gauguin's "sacrifice" and his probably extraordinary experience of paying rent in advance, was a well-known personage to many of the impecunious artists of the Quartier.

In exchange for her milk, pictures were quite welcome, and now she has retired in comfort to Noyon—the owner of quite a valuable collection of paintings, among which are several of Gauguin's.

XIV

September (?), 1893, Paris.

My dear Daniel:

At last a letter from you. "What has become of Daniel?" Meilheurat asked recently.

So the climate of Algiers is not marvellous? It's freezing here, too, just now. I'm just back from a six-days' trip in Belgium. It was fine. I saw some Memlings at Bruges—what marvels, my dear fellow, and afterwards on seeing Rubens (entering into naturalism) it's a comedown.

I'm writing in haste to reply to you and to tell you that at last the lawyer has placed the money into my chaste hands; I write you this for I want you to know it; that is to say, now you need not worry about cash.

Well my oration is finished. A friendly handshake to Barbin. Gracious remembrances to the red-haired child.

Cordially yours,
Paul Gauguin

* * *

The three previous letters date from the first hopeful and lighthearted months of his return. But in the long interval—a full year—it seems, which lies between them and the letter that follows, containing his bitter decision to return forever to Polynesia, his life was dogged by a series of peculiar mishaps.

The show at Durand-Ruel's was a complete fiasco. Of the forty-four canvases exhibited only eleven were sold, and though many of these now rank among his masterpieces, the press and public, as well as the arbiters of official art, were almost unanimous in their contemptuous criticism of his work.

After the exhibition Gauguin withdrew angrily to his beloved Brittany; yet even there where, before, he had found rest and healing, he was followed by a malicious fate.

In Paris he had become infatuated with a young Javanese girl, and he had taken her with him to his retreat in Brittany. One night in a café she was insulted by some drunken peasants. In the fracas which followed, Gauguin, who was a practised boxer, put the crowd to flight, but during the scuffle his foot was struck by a wooden sabot and the ankle broken. Immediately after, the woman deserted him, and he spent months of suffering in a hospital, where his foot was so badly cared for that it never entirely healed.

So at last, as he writes here to de Monfreid, he returned to Paris and arranged for another sale of his belongings.

In order to assure his existence in Tahiti, he entered into, as he thought, binding arrangements with certain of the dealers for the sale of his pictures, and for the collection of money due him from various individuals for objects bought at his sale. These arrangements seem to have been difficult of fulfillment, and, in his impatience to leave Europe, he probably relied too much on promises of payment that were never, or only tardily, carried out.

XV

October–November, 1894.

My dear Daniel:

Yes, I don't send much news to anyone, and everyone is complaining. You see it is because I have lost courage. I am suffering so much, especially at night when I can hardly sleep.

And for this reason, naturally, I am doing nothing. Four months thrown away and many expenses! Besides, I have come to an unalterable decision—to go and live forever in Polynesia.

I shall return to Paris in December, and busy myself entirely with selling my collection, no matter at what price—everything. If I succeed I shall leave in February. Then I can end my days in peace and freedom, without thought of tomorrow and this eternal struggle against idiots. This time I shall not go alone. An Englishman and a Frenchman will go with me for two or three years, but *I* shall remain.

Farewell to painting unless as an amusement; my home will be in wood-carving.

I see by your letter that you are happy in the South and that you and Annette are in the best of health. That means good work. I had a long and sad letter from Z——. I fear that within a year he will be a hopeless hypochondriac. It is not cheerful and does not tend to make me wish to remain longer in this filthy Europe.

While awaiting better days, I press your hand cordially.

Tout à vous

Paul Gauguin

* * *

This next speaks for itself. He is in Tahiti again, and we can almost see him, as many of the horrified whites described him there, clothed only in a pareo, his long golden hair mixing with his unkempt beard, squatting by night in the native auberge, speaking the language, and taking his deep gusty pleasures with the dark-skinned race, not unmindful, but rather blatantly contemptuous, of the wagging tongues of his compatriots.

XVI

November, 1895.

My dear Daniel:

As your kind letter comes, I've not yet touched a brush except to make a stained glass window for my studio. While making a decision I've had to camp here in Papeete. Now I'm having a large Tahitian house built in the

country. The site is wonderful, in deep shadow on a roadside, and from behind, a wonderful view of the mountain. Imagine a great birdcage railed in with bamboo, its roof thatched with coconut leaves, and divided into two parts by my old studio curtains. I use one partition as a bedroom, with very little light for the sake of coolness; the other forms the studio and has a large window at the top. Mats and my old Persian rug cover the floor; it is all decorated with hangings, knickknacks and drawings. So you see I have not much to complain of just now.

Every night some mischievous little rascals come to sleep with me. I had three to attend to yesterday. But I'm going to stop this truckdriver's life and get a sensible woman into the house. Then work without interruptions, especially as now I'm just in the mood for it, and I believe that I shall do better things than ever before.

My old sweetheart got married in my absence; so I was obliged to fool her husband, but she can't stay with me, though she did run away to me for a week. . . .

So now you are doing decorating, and in London. I shall be so glad if your trip is productive, or, at any rate, interesting. I see by your letter that you have been in the South and that you are busy with the divorce. But you don't tell me how it is turning out. Inevitably one makes so many troubles for oneself by marriage—that stupid institution!

I see, too, that Maillol is involved. I wish him good luck, but I fear for him and it would be a pity, for he is a fine fellow and an artist.

And see what I did with my household; I cut loose from it without warning. My family will get out of its scrapes by itself, so far as I am concerned! I want to finish my life here, in this house, in perfect quiet. Ah, yes, I am a great criminal. What does it matter! So was Michelangelo; and I am not Michelangelo.

Many greetings to our friends and to Annette.

<div style="text-align: right">Yours as always,
Paul Gauguin</div>

XVII

<div style="text-align: right">April, 1896.</div>

My dear Daniel:

Whatever the news, I always receive with pleasure the letters of the few friends who still think of me. I know that you have the best of intentions, but I fear that you cannot be of much help. I am not only at the end of my resources, but at the end of my strength. I've exhausted everything, and at the moment my will is very weak. Since coming here my health has been growing worse. I suffer terribly from my foot. There are two sores and the doctor is not able to make them heal; in warm countries that's bad. When

night comes I have spells of violent twitching which keep me awake until midnight. You must admit that my life is very cruel. During my first stay in Tahiti I made unprecedented efforts and you saw the results in the Rue Lafitte; and what have I come to? To a complete defeat. Enemies—that is all. Ill-luck has pursued me my whole life, without rest. The further I go, the lower I descend. Perhaps I have no talent, but—all vanity aside—I do not believe that anyone makes an artistic attempt, no matter how small, without having a little—or there are many fools. In short, after the effort I have made, I can make no more unless it bears fruit. I have just finished a canvas of 1.30 by 1 metre, which I think is the best thing I have done. A nude queen is lying on a green rug, a servant is picking fruit, two old men near a large tree discuss the tree of knowledge; a seacoast in the rear. This shaky sketch gives only a vague idea of it. I think I have never done anything so deeply sonorous in colour. The trees are in blossom; a dog stands guard; on the right two doves are cooing.

Of what use is it to send on this picture, when there are so many others that do not sell, and only make people shriek? This will only make them shriek still more. I suppose I am doomed to die of good will, so as not to die of hunger.

And to know that there are old men who behave with the greatest carelessness, and that the life of an honest man depends on them! I mean Levy. If it had not been for him I should never have dared start for Tahiti; but it was he who proposed it to me. "You can go down there quietly, and we will not let you get into any difficulties. Perhaps it will take time, for it is not easy to make people swallow your work, but I will do what is necessary." And already he doesn't want to bother with it.

So I left confidently, after making these calculations that were not erroneous:

Café proprietor	2,600	francs
Mauffra	300	francs
Framer for Mauffra	600	francs
	3,500	francs

then 800 francs for a picture I sold, payable in May. This was what I thought would allow me to live quietly for a time and wait for Levy to sell some of my pictures. Now everything is crumbling. I don't get anything from anyone. If the café proprietor has gone broke, his collection is there that they could have sold, in part anyway. He has several van Gogh's, a very nice old-time Pissarro and a little study of Millet's. My God, what does it mean? I am afraid that someone has stupidly irked Levy, who is a very straight man, and he has told them to leave him alone.

I've actually had to borrow 500 francs, so as to have enough for the next few months. With the five hundred that I owe on my new house, it mounts up to a debt of a thousand francs. And I am not extravagant. I live on a

hundred francs a month. I and my vahine—a young girl of about thirteen. You see that isn't much. Then, besides, I have my tobacco to pay for, and soap and a dress for the youngster, coming to about ten francs a month.

And if you could see my place! A thatched house with a studio window. The trunks of two coconut trees, carved into figures of Kanaka gods, some flowering arbutus, a little shed for my horse and carriage. It's true, I went to some expense to settle myself here, so I won't have to rent anything, and can always be sure of sleeping under my own roof; but who wouldn't have done the same, considering the money due me, that I await in vain?

It was a good idea of yours about the picture sent to my wife, but poor Z—— thought he was doing the right thing, and I shall not blame him. He has always had a soft spot for her, and believes that she is unhappy. I know, through several Danish sources, that my wife is happy, leading a life that suits her, and that she is protected and petted by everyone. She is far from being penniless, while I have nothing. But had I sent her 6,000 francs, instead of 1,500 from my uncle's 13,000, what would have become of me? For now I am without funds and without any way of earning my own living, as my painting does not sell.

My wife can sell my pictures and buy herself buttertarts with the money. Yet, on the other hand, it is better for my pictures to be placed with Danish art lovers than to lie about in the back room of a shop.

It is hard to beg. Could you not see Meilheurat, show him my letter if necessary, and ask a thousand francs from him? I will pay them back later, as soon as my affairs have cleared up. Then I will send him the picture I told you about, and he can keep it as a guarantee, unless he would like to have it.

So many people are protected because their weakness is known, and they know how to ask. No one has ever helped me, for they thought me strong, and I have been too proud. Now I am cast down, feeble, half-exhausted by the merciless struggle. I kneel and lay aside all pride. I'm nothing but a failure.

My great consolation is music. I don't know how I did it, but I broke the strings of my guitar. Be good enough to send me two complete sets, and besides:

6 D strings
6 E strings
3 G strings

the best quality, for they break easily here.

I'm writing Z—— a letter similar to this, but shorter. You know how touchy he is, so it's useless to show him this letter; he would think that you are the privileged person. I see, my poor friend, that you too are having lots of trouble through your wife. What a thing marriage is!

A handclasp to Annette and to friend Maillol.

Yours as ever
Paul Gauguin

* * *

There is a gloom in this last letter, though separated by only six months from the exhilarating and carefree epistle which had gone before. All the old burdens are reflected here, and above all the bitter hurt of neglect. Yet from other sources we know that, though greatly worried by his pecuniary situation, he was working steadily; and the slight picture given here of his Tahitian house, with its carved Kanaka gods, and the flowering arbutus at the door, brings to mind that other book, *Noa Noa*, written in collaboration with Charles Morice where many of the more romantic incidents of his life may be found—those exoticisms in which the jaded Parisian taste was apt to take delight. But however touched-up portions of the picture may be, there is in it an almost mystic reaction to the native life which is obviously sincere.

His relations with his little vahine, a child of thirteen, as complicated a creature as any Parisienne in her twenties, are a curious study in feminine psychology. And he seems to have loved this dark-skinned Tehura as only the blasé and wearied European, exasperated by the cold perversities of the Western cocotte, might love a beautiful girl of this strange race.

The story of his journey to the mountains and of his courtship there is told in *Noa Noa*. Disgusted by the snobbery and stupidity of the colonial French, he had left Papeete for Mataiea, a native village some forty kilometres away. But after his parting from Niti, a half-white courtesan from the town, he was lonely and restless. At last, with a vague project in mind, he set off into the mountains on horseback. I translate here from *Noa Noa*.

"As I passed through the district of Faone a man, a native, called to me.

" 'Ohé, thou man who makest human beings, come and eat with us.' The smile that accompanied this invitation was so engaging, that I halted and got off my horse. And I entered with him into a hut, which was full of men and women, talking and smoking. Children were playing all about.

" 'And where art thou going?' asked a handsome woman of perhaps forty years.

" 'I go to Hitia.' 'And for what reason?' Then suddenly expressing a desire which till then had been hidden almost from myself, I replied:

" 'To find a wife.'

" 'The women of Faone, too, are beautiful. Would you like one?'

" 'Yes.'

" 'Good, I will give her to you if you like. She is my daughter.'

" 'Is she young?'

" 'Yes.'

" 'Pretty?'

" 'Yes.'

" 'And she is not ill?'

" 'No.'

Tahitian Woman in a Landscape (painting on glass), 1893

" 'Very well, I will see her.'

"And the woman went away. A while later, during a delicious meal of wild bananas and shellfish, she returned with a young girl who held a small bundle in her hand. Her dress was of pink, transparent muslin, through which gleamed the golden skin of her arms and shoulders. Her breasts were like two swelling buds. She was tall, strong and slim, splendidly proportioned.

"I spoke to her and, smiling, she sat down beside me.

" 'You do not fear me?' I asked.

" 'Aita' (no).

" 'Would you like to come with me and stay in my hut?'

" 'Eha' (yes).

" 'You are not ill?'

" 'Aita' (no).

"The girl sat by me quietly, arranging food on a large banana leaf, then offered it to me, and my heart beat curiously. However I ate with enjoyment, but I was deeply troubled. This girl of about thirteen years (she would have been eighteen or twenty in Europe) charmed me, yet I felt timid, almost frightened. What might be in her soul? I thought. Perhaps it is only in obedience to her mother's command. Perhaps it is an arrangement they have agreed on among themselves. . . .

"But on looking at her I was reassured. For in her manner and gesture were pride and independence, and my faith came back when I noticed upon her face the calm contentment which, in those still young, so often is the accompaniment of an honourable and laudable act. Yet there were mocking lines about her lovely, tender and sensual mouth, and I felt the real dangers of this adventure might be less for her than for me.

"Then came the hour of departure; but before leaving I had to give her mother a promise that she might come home for a visit at the end of eight days, and that if she were not happy she might remain with them, unmolested by me.

"At Taravao I returned to the gendarme the horse which I had rented for the trip, and an unpleasant thing occurred. His wife was a Frenchwoman, and she said to me, without intentional malice, but tactlessly:

" 'How! You bring such a hussy back with you?' And with angry eyes she examined the young girl, who met her insulting scrutiny with a complete indifference.

"The two women offered a symbolic spectacle. On the one side was nature and trust and a delicious blossoming of natural things. On the other, barrenness and law and artifice. The two races met there face to face, and I was ashamed of mine. How ugly and intolerant and contemptible it was. And I turned from it quickly, to feel again the warmth and joy and glamour of the other—this living gold that I already loved.

"At Taravao her family, that had accompanied us thus far on our journey, parted from us—just at the Chinaman's hut—that Chinaman who sells everything, liquor and fruit and clothes and weapons, and beasts and women and men. . . .

"And my wife and I took the stagecoach which left us twenty-five kilometres further on, at Mataiea, where I lived."

Now at last it seemed as if Gauguin were truly happy. The days followed one another softly and without care. After the promised visit to her people his wife returned, and to Gauguin, who had feared that she might decide to leave him after all, this return was a joyous event. He welcomed her, this bitter and blasé European, this savage whom most white women disliked and feared, with the simplicity and clear joy of a youth. But one day he was forced to go to Papeete on business.

"I had promised to return that evening," he says, "but the coach went only halfway and I had to do the rest on foot. It was one in the morning before I reached our house.

"I opened the door. My heart sank. The light was out. Trembling with fear and dread I struck a match quickly, fearing that she had gone.

"Tehura, immobile and naked, was lying face downwards on the bed, her eyes dilated with fear. She stared at me without recognition. And I myself stood there for some time, strangely uncertain. I, too, felt the terror of Tehura. A phosphorescent light seemed to stream from her eyes. I had never seen her so beautiful. And in the darkness which must be for her full of ghastly apparitions, I was afraid to move, for fear of increasing the child's fright. Perhaps she would think me one of the demons, one of those Tupapaus, which the people of her race think rove about through the night. And did I really know who she was herself? She seemed changed into a strange being, different from anything I had ever known.

"At last she came to herself, and I talked with her, and tried to reason with her and to restore her confidence.

"Sulking, she listened to my words, and then said in a trembling voice, 'Never leave me alone again without light.'

"And scarcely had her fear been assuaged when she asked with jealousy:

" 'And what did you do in town? I know that you have been with the women who dance and drink in the marketplace, and who give themselves to all the world.'

"But I would not quarrel with her. I kissed her softly, and the night was glamourous . . . a tropical night. . . ."

All during this month of June, Gauguin was in the hospital, suffering terribly, both mentally and physically, unable to afford proper care. And here he outlines a plan, which, though it ultimately failed, was instrumental in gaining the interest of Vollard, a Parisian dealer, who, later, took much of Gauguin's work.

XVIII

June, 1896.

My dear Daniel:

An idea has come to me; you can understand that while I am ill in bed, I do nothing but turn things over in my mind, trying to find a way out of my difficulties. This is what I have thought of and it seems to me to be possible, if not easy. Were I in Paris I would certainly do for another what I am asking for myself.

Find about fifteen people who either understand my work or who wish to make money out of it. Make them this proposal:

Each year I will send fifteen good canvases in advance, done like the former ones. For this merchandise these people will send me 2,400 francs a year, which means 160 francs each. As for their distribution, that is, to know to whom each picture should belong, they could draw lots—first, second, etc. . . .

It is certain that my pictures are not expensive at this price, and in a short time the purchasers could not lose. Here is a list of the people you could see (but with a great deal of eloquence):

Portier, the art dealer
Thomas, the art dealer
Lerolle, painter
Rouart, painter and engineer
Jean Dolent. See Z—— who knows him.
Sérusier—
His pupil at Versailles who carves wood as I do.
Meilheurat
Le Comte de la Rochefoucault—he gave both Bernard and Filiger an allowance of twelve hundred francs.

There is nothing very honourable about this for any of them; but it is a way to help an artist in whom one believes, without forcing him to accept charity.

Some of them may say that they are not speculators; it is a stupid evasion, because it is all the same whether they buy at low prices from a dealer, at an exhibition, or from me; besides, the scheme allows an artist to work, which is the important thing. This then is my plan, and it seems to me it will not be very difficult to put through if we go about it in the right way.

The devil! I am not greedy. To make two hundred francs a month (less than a labourer) at almost fifty years of age, and with a pretty fair reputation. . . .

It is needless to say that never having sold trash, I shall not begin it now. The pictures I send will be done just as well as were the former ones that I did for my exhibition. If I resign myself to poverty, it is because I wish to do nothing but art.

When I left my wife in Denmark, I left all my household effects, linen, etc., as well as sculpture and paintings. My collection was bought for about

15,000 francs. Plus quite a number of old canvases of mine, plus the canvases and ceramics you have sent during my stay here. I estimate the sale of all this at 30,000 francs, plus 4,000 francs that I have sent on several occasions. I have only drawn the 600 francs you know of, in '93, '94—and I have always lived like a tramp.

So my instructions to prepare for my future by selling in Denmark have proved useful only to my wife, without any possibility of benefit for me. I am sure that the consignment of canvases sent by Z—— will be quickly sold and that my wife will ask for more.

Here is what I wish done. When my wife asks for canvases, write her that, according to my irrevocable order, you may send three canvases only against an advance of 400 francs.

I wish, in short, one-third of the sale price of my pictures, and, as I have no confidence, I wish it in advance. That is understood.

You say in your letter: "You, the strong man, are you cast down?" Yes, I am prostrate and seem to lose all my energy when I think of the present and of the future. My strength is gone, utterly exhausted by days and sleepless nights of suffering with my foot. The whole ankle is one great wound, and has been that way for five months.

When I work I am distracted and gain strength; but without work, almost without food and without money, what will become of me? No matter how strong one is there are walls one cannot scale.

Many thanks for all the trouble you are taking.

Cordially yours,

Paul Gauguin

Made at Tahiti this 12th day of June, 1896.

This Agreement, made in all freedom, in no spirit of future recrimination and to assure for five consecutive years my art work.

I agree to send every year in advance fifteen canvases conscientiously executed according to my artistic faith which will be divided between the signatories of this Agreement which binds them to send annually the sum total of 2,400 francs.

Paul Gauguin

XIX

July 13th, 1896.

My dear Daniel:

A few hasty words for this mail. I am in the hospital, almost at the end of my suffering, for I hope to be better in a month; but how shall I pay? Last month you and Z—— said that money would come. A mistake. Mauffra excuses himself, large and unforeseen expenses having kept him from

sending any. . . no money this month either and no letter from anyone. I shall go mad and am completely broken.

I write you this month, as an officer is going back to France and will take some of the canvases with him, though they are not very good on account of the condition I am in; and besides, my temperament forces me to do a picture feverishly, all at one swoop—but now, working only an hour or so a day.

However, such as they are, I shall send them. Perhaps they are good. In them is so much of agony that perhaps the awkwardness of the execution may be overlooked. Mauclair says my coarseness and brutality are revolting. What iniquity! I am tired!

<div align="right">Cordially,
Paul Gauguin</div>

<div align="center">XX</div>

<div align="right">August, 1896.</div>

My dear Daniel:

I receive a letter from you and from Z——. That is all. Both of you think that I have gotten money from Mauffra, but no. So, though I have been here for a year, and in spite of their knowledge of my position, I do not get a centime from those who are in my debt. You must admit that it is enough to make the strongest man despair. I come out of the hospital, and imagine my feelings on having to admit that even later I would only be able to pay 140 francs.

Thank God, I suffer no longer, though only about half cured; but I am very weak and have only water and a little boiled rice for nourishment.

Z—— has written me a really senseless and unjust letter, and I do not know how to reply, for his is truly a sick soul. His exhibition was a complete failure, so now he thinks himself far more unhappy than I, who have fame, strength and health! Imagine it! I have the gift, he says, of making other people jealous. And he adds: "If you had been careful and far-seeing you would now be on Easy Street, and with a little more care and a little more kindness and friendliness towards your contemporaries, your life would be very happy."

Eh bien, I question my conscience: I can't find anything. I have never been mean, even to my enemies; on the contrary, at the most difficult times of my life I have more than shared with those who were unfortunate, and my reward has been to be thrown over completely. I saved Laval from suicide and have given away more than half of what I possessed. I helped B—— both with money and influence. You know what happened. I fought for others: they broke my leg for me. During my last stay in France I was as kind as possible to the W——'s and always with purse in hand. No letters from them. . . .

That is how unsocial I am. I admit that my words are sometimes sarcastic, I do not flatter, bend my back, and sneak about begging in the official salons. Now Z—— wants to petition, and I think uselessly, for the State to come to my aid. It is the thing I should dislike most of all. I ask *friends* to help me until I can get the money that is due me, but to beg from the State has never been my intention. All my struggles to keep clean, the dignity I have forced myself to maintain all through my life, would lose their character on that day. From then on I should be no more than an intriguing rascal. But if I submitted—yes, it is true enough—things would be easy for me. Truly, this is a sorrow I did not expect to have to bear. I was born under an unlucky star.

I see from your letter that you are not happy and that your wife is treating you atrociously. Z—— , who sees only his own trouble, would say to you, as he says to me, that you are hard on her. We see the mote in our wife's eye and fail to see the beam in the eye of our neighbor's wife.

A handshake from your devoted

Paul Gauguin

* * *

In the meantime a few hundred francs had come, and he was able to leave the hospital, so we see him now, encouraged and eager for work, with the most pressing of his debts disposed of.

XXI

November, 1896.

My dear Daniel:

I received only one letter—yours. Yes, I'm beginning to get better, and am taking advantage of it by doing a lot of work, sculpture. . . .I strew it all over the grass. Clay covered with wax—first it's a woman, a nude, then a superbly fantastic lion playing with its little one. The natives, who know nothing of wild animals, are very much excited over it.

Just imagine, the Curé did everything possible to make me take in the lady who wore no clothes. The judge laughed in his face and I sent him properly about his business. Ah, if I only had the money that is owing me, my life would be extraordinarily calm and happy. I shall soon be the father of a half-caste, my charming dulcinea has decided to lay. My studio is very beautiful and the time goes quickly. I can tell you that from six in the morning until noon I can do a lot of good work. Ah my dear Daniel, if only you knew this Tahitian life you would not want to live in any other way.

Yours cordially,

Paul Gauguin

XXII

February 14, 1897.

My dear Daniel:

On the 6th of February I received your letter, dated November 26th, which proves that our postal service is pretty well organized. As for showing the canvases (the Independent Secessionists) I must tell you that I am not in the least partial to exhibitions. That fool of a Z—— can only think of exhibitions, publicity, etc., and cannot see that the result is disastrous. I have many enemies and am fated to have them always, and even as time goes on, to have more and more; so whenever I exhibit they wake up and yelp. They disgust the art lover and they weary him. The best way to sell is in silence, always working with the dealer. Van Gogh alone was able to create his own clientele; today no one knows how to tempt the amateur. There are those who, thinking themselves very clever, deny this. We must prove that they are wrong; that the right way is to leave a picture six months or a year with a serious amateur, and when he has seen it over and over again, compared it, learned to love it, then he can buy it or give it back. That is the correct way to show my pictures. Try to persuade the dealers that this is a good system. As for the price, we must not be too difficult. When there is a crowd of buyers after them, there will always be time to raise. I have no thirst for glory or luxury. I want nothing but to live here quietly in my adorable place. If ever you should be free, if your mother should die, I would strongly advise you to come here with an income of 200 francs a month. The life is so serene, so favourable to artwork, that it is madness to seek for anything else. . . .

I shall send you some of my canvases in the near future; I cannot even judge them, my moral and physical suffering has been so great. You will see all this more clearly than I.

Nave Nave Mahana—Delicious Days.

Note aha oe Riri—Why Are You Angry?

A Bouquet of Flowers.

Barbaric Poems.

Still Life.

A Self-Study.

I offer you this last as a very slight token of my regard, of my friendship, in return for all your devotion. And if there is any other canvas that pleases you, take it. I should be very happy to give it to you.

I am trying to finish another canvas to send with these, but shall I have the time? I want you to notice the vertical sketch when you stretch it. Perhaps I am mistaken, but it seems to me to be good. I simply wished to suggest with the simple nude, a certain barbaric luxury of ancient times. Voluntarily it is bathed in sad and sombre colours. Neither silk nor velvet nor cambric nor gold forms this luxury, but only the medium, made rich by the touch of the artist. No it is the imagination alone, which, with its fantasy, has given richness to the abode.

As a title—*Nevermore*. Not at all the Raven of Poe, but a lurking Devil-bird. It is painted badly (I am so nervous that I work in streaks). But it doesn't matter, I think it a good thing. A marine officer, I hope, will send you the whole lot within a month. . . .

Will you be good enough (another commission) to order from my shoemaker, Tholance, 4 rue Varin, a pair of laced boots. I wish Russian leather, as supple as possible; not lined. Like women's boots, with eyelet holes; something like a clown's, laced almost from the bottom. I say "eyelet," i.e., holes pierced in the leather; the sole projecting well beyond the upper and the toe very square. My sore foot demands absolutely a footwear seamless inside and capable of being tightened at will. With this, a large sized bottle of red polish. Make the best terms you can.

A cordial handshake. All yours,

Paul Gauguin

XXIII

12 March, 1897.

My dear Daniel:

You will receive with this letter the canvases I spoke of last month, as the warship's departure was postponed for ten days. I took advantage of the delay to do another canvas, which seems to me even better than the rest, in spite of the haste of the execution. *Te Rereioa (Le Rêve)* is the title. All is dream in this canvas, whether it be the child, the mother, the horseman in the path, or the dream of the painter?

All this is apart from painting, they will say. Who knows? Perhaps not—

Just now I feel better and ready for work. I shall make up the time I lost and the number of my canvases may threaten to encumber you . . . give them to Chaudet. But as there are so few buyers, take out some of the best of each shipment, show them to our friends, and put them away in your garret. It is better to keep the best for the day (hoped for anyway) when I can get better prices for them. Above all, do not let Z—— meddle with them. He would cram me into an exhibition with Bernard, Denis, Ranson, etc., which would give the *Mercure* the chance to say that van Gogh and Cézanne are the real leaders of the modern movement. No, you see, exhibitions are of no real use to me, except to catch me unjustly and to mix me up with God knows whom. At an exhibition in London that I remember, they said, "Monsieur Degas seems to be quite a good pupil of de Nittis."

By tomorrow I shall have become the pupil of Bernard and of Sérusier. In sculpture the pupil of Paco.

You told me in your letter that you continue to paint as you did fifteen years ago. You are mistaken. What you showed at the Indépendants last time in '95 was not at all like your work of fifteen years ago. You are right to work

with dignity and not run around like Z—— after the toy of a human halo; but it is useless to efface yourself for the pleasure of self-effacement.

<div align="center">* * *</div>

The letter of the following month speaks volumes. However indifferent Gauguin seems to have been to the ordinary family responsibilities as we know them, the death of this daughter came to him as a brutal shock, the unexpectedness of which his implacable wife made no attempt to soften.

It would be interesting to clear up some of the dimnesses that have settled over his relations with his family and his wife. With a little encouragement perhaps, the ghosts would peep and wink from hidden corners. But the only curious occurrence of which I shall make note, is the finding of a small manuscript left half-finished at the time of his death in the Marquesas Islands. It was entitled "The Advice of a Father to his Daughter." Just what this advice was it would be interesting to know. It was never published, and now I understand that all trace of it is lost. Rumour goes that it was cynically ironical, the worldly wisdom of a bitter and broken-spirited man.

But after the death of this daughter he wrote:

"I have just lost my daughter. I no longer love God.

"Like my mother she was called Aline.

"We all love in our own way; some love exalts even unto the sepulchre.

"Others . . . I do not know.

"And her sepulchre is there, with flowers? It is only an illusion.

"Her tomb is here, near me. My tears are her flowers; they are living things."

And to those for whom Gauguin has seemed so often only the harsh and ruthless fighter, whose ironic tongue lashed friends and enemies alike, these touching words come as a curious surprise.

<div align="center">XXIV</div>

<div align="right">April, 1897.</div>

My dear Daniel:

Your letter arrives at the same time as a short and terrible letter from my wife. She tells me brutally of the death of my oldest daughter who was carried off in a few days by pernicious pneumonia. The news did not move me particularly, I have grown so used to suffering. Then each day memory comes back, the wound opens more deeply, and just now I'm completely discouraged. Surely in the heavens I must have some enemy who will not give me even a few peaceful moments.

Just now when I was getting on my feet, and had enough money to be able to work for a few months, I am hit again. The woman who rented me the bit of ground on which I built my house has just died, leaving her affairs in a bad

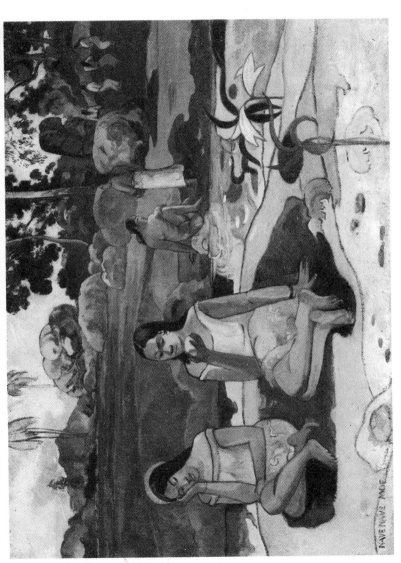

The Miraculous Source (Sweet Dreams), 1894

state, and in consequence the property has been sold. So here I am in search of another piece of ground, and I shall be forced to rebuild; it is enough to drive one mad.

I have received from Z—— his absurd portrait of me in "The Men of the Day." That fellow makes me tired; gives me the shivers; the fool. And what pretension! A cross, flames. Bah! There you have symbolism.

Yours in all friendship,

Paul Gauguin

XXV

May, 1897.

My dear Daniel:

In the last mail I received that letter from my wife with the bad news. I'm somehow getting used to it, and anyway I wrote you of it. The confusion of all sorts that I am in now is a good thing, probably. It keeps my thoughts away from this unhappiness.

Without a plot of ground, obliged to tear down my house, and without news from Chaudet for three mails, in spite of the fact that he promised me 800 francs in the next mail, plus the 150 owing me from the café man, and unable to look ahead clearly, I've come to a desperate remedy. By an effort of will, and vanquishing my pride, I begged, supplicated and intrigued, till finally I was able to obtain a loan of 1,000 francs from the Caisse Agricole (Banque de Tahiti) for a year. With it I bought a bit of ground for 700 francs (too large for me, but it was all there was for sale) quite near to where I was before. With the 700 francs remaining I have rebuilt and have gotten settled again. And I still have 200 francs for living expenses. Later I will get back the price of my property, for there are about a hundred coconut trees on the place, which should bring me in about five hundred francs a year. And besides if I am obliged to sell some day, the improvements I will make will augment its value. If my health allows it, and I have still a few sous to spend, I intend to plant some vanilla, which pays well, without being too much work. Who knows! Perhaps some day I can be really free and out of all difficulties. . . .

And from now on you are free, and rid of your wife. I congratulate you. As for the distribution of your property, I can't say anything for I don't know whether it will be to your advantage. Justice in these cases is generally partial to our ladies. I think I am on the road to recovery, but it will be a long siege and my feet are still in bandages.

But it doesn't matter, for I am not suffering and can work a little. I've begun, I think, a lovely canvas (*The Dwelling-place of Souls—Te Rohutu*). I include a sketch, but only for your amusement, for it really gives little idea of it, the colour being always very important. What more shall I tell you about, expect that I am so thankful for your monthly letters.

Many months, as this for instance, you are the only one who writes to me. I wrote to Degas almost a year ago, but have had no answer. I fear that the stupidities of Z —— may have given him a worse idea of me than he had before. My regards to Maillol.

<div style="text-align:center">

Cordially always,

Paul Gauguin
</div>

<div style="text-align:center">✻ ✻ ✻</div>

The frantic and despairing letter which follows marks the beginning of a series of tragic disappointments and worries, mostly financial, but doubly hard to bear through the continuous physical suffering that accompanied them. They were not necessary. His work sold steadily, though the prices, especially today, seem pitifully small; but trouble arose through the neglect and dishonesty of the Parisian dealers on whom he had to depend. He writes here, as so often, with monotonous reiteration:

"Chaudet has not written a line for four months—if he were angry you would know of it."

The Chaudet mentioned here seems not to have been a rogue, but rather an erratic though fundamentally honest dealer, in whose hands Gauguin had left many of his financial affairs.

The letters are often from this time on a succession of pleas to de Monfreid for the collection of the money which he had depended on to make possible his Polynesian life. I have omitted much of this, giving only a brief outline of those terrible struggles for mere existence, the details of which are often difficult to follow. Yet how pitifully small was the sum on which he could have been content and happy! Forty dollars a month—and each forty dollars meant the acquisition of one of his paintings—yet for years even this sum remained impossible to compass. And assuredly had it not been for the devotion of Daniel de Monfreid, Gauguin's existence would have been doomed from the first.

<div style="text-align:center">

XXVI
</div>

<div style="text-align:right">

July 14th, 1897.
</div>

My dear Daniel:

My illness has grown worse. The money sent by Chaudet did me so much good, then—all these last worries have done me up. I don't know what will happen—in debt and without a cent; a diet of rice and water every day does not help me to regain my strength. I have fits of dizziness, attacks of fever, and the suffering in my feet is so intense that I have to remain in bed or on a chair. No more brain, no more work, and without hope. Chaudet has not written me a line for four months, if he were angry you would know of it.

The café proprietor should give him 150 francs a month, and if I had them they would be a help, as well as the two hundred francs that you say are there for me. . . .

And now to reply to your letter. So I offered you a canvas; see what a head I have, I can't remember it. But I congratulate myself on having had this good idea and I am very glad you chose the skiff. You think it romantic. Why not? And then Delacroix! Well you know that though others have honoured me with a system, I haven't one and would not be condemned to one. To paint as I like, dark today, bright tomorrow, and anyway an artist must be free or he is not an artist.

The canvases which I sent reached you safely and you admired them. So much the better. I was afraid—for I can't judge them in my present state. But you reproach me seriously, that I am not careful enough with the material. Oh, yes, I am careful with it, especially in painting. But the preparation leaves much to be desired. But in the nervous state I'm now in, the preparation worries and tires me. . . .

Then the canvases of which you speak were rolled, while I was in the hospital, by a naval officer who did not know how to do it. Tossed about for two months, with no air and in extreme heat, they ran great risks. Once stretched and varnished, the risk is not so great. In case of disaster, Portier has an excellent transferrer, and that costs twenty francs or so; otherwise, this is what you can do: paste paper with library paste onto the painted side; then turn the canvas, stretch it on a plank and pour over it thin paste, almost cold. Spread well with a knife and wipe it so that the paste passes underneath through the Spanish white. Once dry, iron it with a moderately warm iron, using as much pressure as possible. Then after the canvas is well stretched on the frame, the paper can be easily removed with a moist finger. What work I am giving you! I repaired in this way a van Gogh, which was peeling all over. If any cracks are still visible what does it matter? In any case, we must do the best we can and it is a long way from Tahiti to Paris. I see no possible means of transport for a year and then I doubt whether I shall have anything to send. . . .

<p style="text-align:center">XXVII</p>

<p style="text-align:right">August, 1897.</p>

My dear Daniel:

I received a charming letter this month from Dr. Gouzer, the marine doctor—who forgot to send me his address. He is all enthusiasm for Daniel, a talented painter and an independent spirit, who received him so kindly, and whose hospitality he abused—so he says. And really it was a great stroke of luck for him during his leave. He also speaks of the necessity of my return to France. With what—and why? If I should return now, I should have

Vairumati, 1897

never left in the first place, unless I had been mad. But what Gouzer says should not be taken seriously, for his intentions are better than his common-sense.

Except for this and a letter from the *Mercure*, I had nothing from you nor anyone else—I do not know now what to think of Chaudet. I haven't a cent and no credit, not even from the Chinaman for bread. If I could walk I would go into the mountains to find something to eat. I was wrong not to have died last year; that would have been better, and it would be idiotic now. Yet that is what I shall do after the next mail, if I receive nothing. . . .

The shoes came and are perfect, but I cannot wear them until I am better, for any sort of footwear hurts me.

You will probably receive this letter in Provence; but anyway you will soon be returning to Paris.

<div align="right">Cordially,
Paul Gauguin</div>

<div align="center">XXVIII</div>

<div align="right">October, 1897.</div>

My dear Daniel:

As every month, only your letter comes; nothing from Chaudet. . . .

I was on the verge of not writing you, for the mailboat came in this time on the 10th and leaves tomorrow, the 13th. Then I changed my mind, for this is almost the last letter I shall write. If I receive nothing by the end of October, I shall have to make my decision. Only it would have been so much better to have told me two years ago what I could expect: it would have spared me so much horrible mental and physical suffering.

Whatever happens I blame no one—and they cannot say that I have not had patience and energy. The material proofs are there. Yet I cannot make a living, no matter how miserable, with this painting, especially if I am away from France. But what would you? Now the ship has no longer a bit of canvas, everything has been carried away and it is going on the rocks. . . . For three months I haven't touched a brush, the colours that you sent me will be useless for the future and here I cannot exchange them for ten sous' worth of bread: it is a bitter joke. I remember those words of Levy, to which Chaudet agreed:

"As you wish to return to Tahiti, here is a scheme that will settle everything." And after each of them had signed the contract you know about, they added: "You may be sure that whatever happens you will always have the necessities of life."

I hope that in France there may be silence, and above all that Z—— will not go around crying: "That poor Madame Gauguin." And as my pictures are unsaleable, that they may remain unsaleable always. Then a time will

come when they will believe me to be a myth, or perhaps an invention of the newspapers. They will ask: "But where are the pictures?" The fact is there are not fifty collected in France.

I weary you with all these complaints but they are the last.

I can see that you are in a productive vein; and of sculpture! Admit now, that it's either very amusing and quite easy, or very difficult. Very easy if one thinks only of nature, very difficult if one wishes to express oneself a bit mysteriously—in parables—to search for forms. What your friend, the little sculptor from the South, would call, deforming. Keep the Persians, the *Cambodgiens* and a bit of the Egyptians always in mind. The great error is the Greek, however beautiful it may be. I am going to give you a bit of technical advice, do with it as you like. Mix a lot of fine sand with your clay. It will make many useful difficulties for you and will keep you from seeing the surface and from falling into the atrocious trickiness of the Beaux Arts school. A clever twist of the thumb, a sleek modelling of the meeting of cheek and nostril. That is their ideal. And then sculpture allows lumps but never holes. A hole is necessary to the human ear, but not to the ear of God. He sees and hears, perceives all without the help of the senses, which exist only to be tangible to man. *Suggest that.*

<div style="text-align:right">Always cordially yours,
Paul Gauguin</div>

<div style="text-align:center">XXIX</div>

<div style="text-align:right">November, 1897.</div>

My dear Daniel:

What I wrote you last month has only been delayed, for I must admit that the 126 francs sent by Annette, though they have given me a month's respite, do not help me much with my creditors. . . .

Now, however, I have changed my decision to end everything, though only in the sense of leaving it to nature. It will take longer, which is a terrible thing for me, but I feel it a duty not to anticipate. My heart cannot withstand so many shocks and the repeated vomiting of blood that comes after all worry and emotion must bring things to a fatal end sooner or later. So I can die without reproach—but when?

At all events, go on in Paris as if nothing were wrong and let me know by each mail how things are with Chaudet.

Z—— writes me as stupid a letter as usual, full of the most ridiculous nonsense, in which there is nothing but talk of his own miserable life, barren of all friendship with his comrades. He hopes *that I am in good health and done with all financial worries.* I am not going to reply. He tells me, however, of one interesting thing; that your *Calvary* is a real revelation—

that it is your masterpiece. I am very glad. If you happen to have a good photograph made, do send a print. Sculpture always comes out well in photography, and in that way I can get an approximate idea of the beautiful thing you must have done. You are right to work independently, and not to send to the Champ de Mars; work for your own satisfaction and not for the petty glory of being crammed into the Seminary of Meissonier and his like.

I was about to forget to speak of your friend, the literary chap. I think he must have a great deal of talent, but I believe that all that should have been said of me has been said, and a great deal that should not. I want only silence, silence and again silence. Let me die quiet and forgotten, or if I must live, let me live more quiet and forgotten still. What difference does it make whether I was the pupil of Bernard or of Sérusier? If I have done beautiful things, nothing can tarnish them, and if I have done trash, why gild it and deceive people as to the quality of the goods? At all events Society cannot reproach me with having taken much money from its pockets by means of lies. If I counted together those of my pictures which belong in one definite place, the number of canvases I have given away is greater than the number I have sold. Not that I regret it; on the contrary. If I had an income of only three thousand francs in Tahiti, I would give them all away. By this I only mean to say that I have never exploited Society. . . .

If you write Doctor Gouzer give him my regards. I have not answered his friendly letter, as I don't know his address, which can't be very settled. These sailors do not remain ashore for long and when aboard ship they are constantly travelling. You made him a wonderful present in giving him a cast of your *Calvary*. And you didn't spend ten years doing it, as did Bartholomé for his tomb; there are works that are pretty fair only through their great importance. These sculptors who do so many Venuses do not think of fusing all their talent, all the best that is in them, into one great work and calling it—well what you like—*Lupanar*, for instance. Then one might say: "There is a noble work." Bosh! What temperament. While you—you do a *Calvary* in one swoop! You understand art, but not your own interests. I can see that you will never be decorated. Well, if Z—— is decorated, what joy. Really it costs the state so little. They should decorate everyone each year who asks for it on official paper.

Thank Annette for her letter.

<div align="right">
Always cordially,

Paul Gauguin
</div>

One never knows what may happen. If I should die suddenly I beg you to keep all my canvases that are in your possession, in memory of me. My family has far too many already.

XXX

December, 1897.

My dear Daniel:

As before, no letter from Chaudet, and, in consequence, no money. And debts enough to pay my living expenses for the year '98. It mounts up to a lot of money, and it will always be that way. You tell me to hold to the mainsail, but you know, being something of a sailor yourself, that one can't hold to the mainsail or even to the mast, unless one can see a little of the foremast anyhow, and a bit of vessel. And I have searched my storehouse in vain for even a few rags of canvas, but I can't find any.

My health goes from bad to worse. And besides lacking the quiet which it is necessary for me to have to regain my lost strength, I haven't even a piece of bread. I live on water and a few mangos and guavas, which are now in season, then sometimes a few freshwater shrimps, when my vahine is able to catch them. I am always hoping either for the money that is owing me, or for the sale of some pictures in Sweden (the exposition) but nothing comes, not even an explanation.

I have received a copy of the *Revue Blanche* with the first installment of *Noa Noa* but, of course, no money.

Always cordially,

Paul Gauguin

XXXI

February, 1898.

My dear Daniel:

I did not write you last month, as I had nothing new to say and, besides, I did not have the courage. As soon as the mailboat came in, having received nothing from Chaudet, and my health being so much better that there was no chance of my dying a natural death, I wanted to kill myself. I went into the mountains, where my body would have been devoured by the ants. I had no revolver, but I had arsenic, which I had saved up while I was so ill with eczema. Whether the dose was too strong, or whether the vomiting counteracted the action of the poison, I don't know; but after a night of terrible suffering I returned home.

All this month I have been troubled by a pressure at my temples, then with fits of dizziness, and I am nauseated at my frugal meals. I received 700 francs from Chaudet this month and 150 from Mauffra; with this I can pay my most pressing debts and go on as before, living a life of misery and of shame until May, when the bank will seize everything that I have and sell it for a miserable sum, including my pictures.

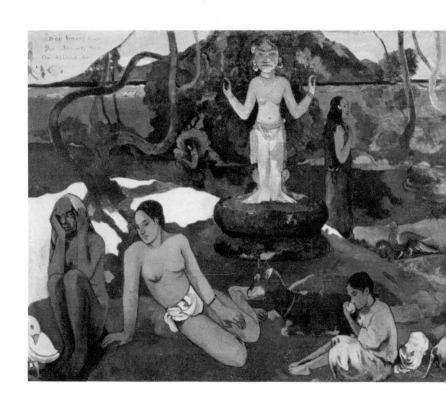

Where Do We Come From? What Are We? Where Are We Going?, 1897

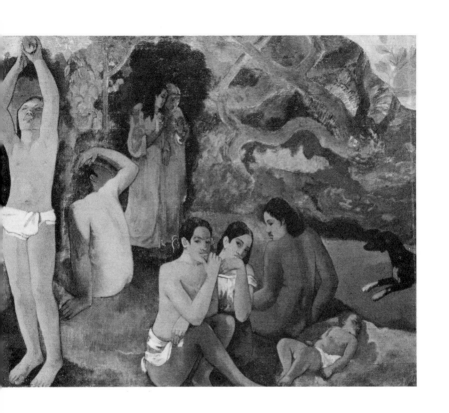

Well, when that happens we shall see about doing something different. I must tell you that my decision was taken for December. But before I died I wished to paint a large canvas that I had in mind, and I worked day and night that whole month in an incredible fever. To be sure it is not done like a Puvis de Chavannes, sketch after nature, preparatory cartoon, etc. It is all done straight from the brush on sackcloth full of knots and wrinkles, so the appearance is terribly rough.

They will say that it is careless, unfinished. It is true that it is hard to judge one's own work, but in spite of that I believe that this canvas not only surpasses all my preceding ones, but that I shall never do anything better, or even like it. Before death I put in it all my energy, a passion so dolorous, amid circumstances so terrible, and so clear was my vision that the haste of the execution is lost and life surges up. It doesn't stink of models, of technique, or of pretended rules—of which I have always fought shy, though sometimes with fear.

It is a canvas four metres fifty in width, by one metre seventy in height. The two upper corners are chrome yellow, with an inscription on the left and my name on the right, like a fresco whose corners are spoiled with age, and which is appliqueéd upon a golden wall. To the right at the lower end, a sleeping child and three crouching women. Two figures dressed in purple confide their thoughts to one another. An enormous crouching figure, out of all proportion, and intentionally so, raises its arms and stares in astonishment upon these two, who dare to think of their destiny. A figure in the centre is picking fruit. Two cats near a child. A white goat. An idol, its arms mysteriously raised in a sort of rhythm, seems to indicate the Beyond. Then lastly, an old woman nearing death appears to accept everything, to resign herself to her thoughts. She completes the story! At her feet a strange white bird, holding a lizard in its claws, represents the futility of words. It is all on the bank of a river in the woods. In the background the ocean, then the mountains of a neighbouring island. Despite changes of tone, the colouring of the landscape is constant, either blue or Veronese green. The naked figures stand out on it in bold orange. If anyone should tell Beaux Arts pupils for the Rome competitions: "The picture you must paint is to represent, *Where do we come from?—What are we?—Where are we going?*" what would they do?

So I have finished a philosophical work on a theme comparable to that of the Gospel. I think it is good; if I have the strength I will copy it and send it to you.

I'm sending you a rather poor photograph of my double house. The one on the left I use exclusively as a studio. I've made it attractive with carved decorations. It's about twenty metres in length by eight in width, with the small garden that I planted. When they sell me out I don't want to have to assist in the destruction of my home.

In about two months I think I shall be able to send on the large canvas. I will try to add some others. N——— writes me that the book is no longer

published by the *Revue Blanche,* but will probably be taken up by Charpentier, which is much better from the standpoint of publicity, and therefore of money. I hope that you are taking an interest in it and will do everything necessary.

Who knows whether this book may not give me a lift and help my painting? At least it will not do it any harm.

I am tired of writing, so I close, taking you warmly by the hand.

<div style="text-align:right">Yours devotedly,
Paul Gauguin</div>

<div style="text-align:center">* * *</div>

The great painting of which Gauguin writes here, executed perhaps under the most sombre and terrible circumstances in which a work of art was ever conceived—painted in a frenzy of creation under the shadow of approaching suicide—is now looked upon as his masterpiece, though its symbolism is enigmatic and was termed incomprehensible by many of its earlier beholders. The description of it given by Charles Morice is admirable and may serve perhaps as an illuminating conclusion to the foregoing letter. He wrote:

"Whether or not this work is the greatest of all Gauguin's paintings, it is certainly among the most beautiful. It is one of those in which one cannot mistake the hand of a master. I do not truly know of any that is more full of the things of the spirit; and it was hardly necessary for the artist to tell us that in this astonishing page his thought stood revealed.

"Astonishing and at first sight disconcerting, it seemed complicated and confused. One is tempted to think the forms too numerous and too varied: these naked men and women, and these men and women in robes; the enormous crouching figure which breaks the perspective, these trees, these two cats, this white goat and the white bird holding a lizard in its claws; the little sleeping child and the dying, decrepit old woman, and the idol . . .

"Then, little by little, under our fascinated eyes the composition is coordinated, the masses become balanced, the lines follow one another, establishing relations between the figures—tacit, fatal, unconscious sympathies, which conceal the most precious secret, the greatest gift of life. And truly—here Gauguin was not mistaken—life runs through it in abundance. It undulates through the woods, it amasses itself in the half-lit places to mirror itself in the calm water of the brook farther on. Against the blue and Veronese green the nude figures stand out—orange coloured. And the thought is not obscure. Is it then an answer to those three questions written on the canvas-edge? No. It is rather the questions themselves. For it is the study of them which makes up human life. The idol, its arms upraised, indicates the Beyond. But is not the idol the work of man? And the old dying woman whose face is so resigned—how far does she consent to disappearance and to death? And the slumbering child suggests the uninterrupted continuance of existence, the endless succession of beings.

"But what of these two purple-clad figures, whose exchange of meditations seems to conclude the work by some grand and noble affirmation of immortality?

"And ever the bird and the lizard are there to remind us—and it is Gauguin who tells us so—of the uselessness of words.

"I do not write these lines as an explanation, or even as a description of this complex work—this marvel of painted literature, which deserves a longer study. The hope and agony of a great and tortured spirit, which, feeling itself called by death, sought to make reply, is rendered here by this veritable Credo of artistic faith, in a plastic outpouring of tenderness and reverie, extraordinarily personal in its ardent, dolorous and mystic purity."

XXXII

March, 1898.

My dear Daniel:

Things have been better this month, thanks to the seven hundred francs that Chaudet sent; and so, unharrassed by creditors, I have been able to rest a little and things look less black in spite of the disaster looming on the horizon for the month of May—twelve hundred francs to pay the Caisse Agricole. I suffer less and the pains in my temples are lighter. But I am so prostrated that I cannot even hold a brush.

Besides, the large canvas has absorbed all my vitality for the present. I look at it by the hour and (I'll admit it to you) I admire it. The more I look at it the more I realize its enormous mathematical faults, but I would not retouch it for anything. It must remain as it is—only a sketch if you like. Yet this question comes up and perplexes me: Where does the execution of a painting commence and where does it end? At that moment, when the most intense emotions are in fusion in the depths of one's being, when they burst forth and when thought comes up like lava from a volcano, is there not then something like an explosion? The work is created suddenly, brutally if you like, and is not its appearance great, almost superhuman?

The cold calculations of reason have not presided at this birth, for who knows when in the depths of his being the work was commenced? Have you ever noticed that when recopying a sketch, done in a moment of emotion, and with which you are content, only an inferior copy results, especially if you correct the proportions, the mistakes your reason tells you are there?

Sometimes I hear people say: that arm is too long. Yes and no. No, principally, provided as you elongate, you discard verisimilitude to reach out for mystery. That is never a bad thing. But of course all the work must reflect the same style, the same will. If Bouguereau made an arm too long, ah yes! What would be left him? For his vision, his artistic will only consists in that stupid precision which chains us to material reality.

To come to the *Revue Blanche*. I don't understand anything about it. I received one number containing the beginning (of *Noa Noa*), and then nothing more; in this way the book will have neither head nor tail, and the money to be had from it will be almost nil. . . .

I think I have said about everything, and have only talked shop.

Your always cordially,

P. Gauguin.

W——— writes me that L———, who is in Norway, has taken two of my canvases. I tremble for them. He is going to marry a Finn this year. I pity the poor girl—if women are ever to be pitied.

<p style="text-align:center">*　　*　　*</p>

The book spoken of here was of course *Noa Noa*. Its unfortunate debut in the *Revue Blanche* was followed by another check. For Morice was unable to find a publisher for it and finally had it printed at his own expense, a course which brought in no money to the artist.

And now the worst befell Gauguin. He was finally forced to give up his painting and to humble himself before the despised Tahitian officials. Month after month went by without the coming of the promised money; his credit "*chez le chinois*"* was exhausted, and so at last we find him working as a draughtsman for six francs a day, which was the sum allowed him by the Colonial Government. He remained at his work for nearly nine months, and so kept himself barely afloat, for several times he had to give up entirely and go to the hospital.

The society of amateurs he had hoped to form—men interested enough in his work to guarantee him an income of 2,400 francs a year, in return for his whole output—had failed. And he lived in fear of having his little property sold up and of finding himself completely destitute. But this last misfortune was averted by his own courageous efforts and by the arrival of a few thousand francs towards the end of the year 1898, thanks to the devotion of his friend. It is with these most difficult months, perhaps, of Gauguin's whole life that the following letters are concerned.

<p style="text-align:center">XXXIII</p>

<p style="text-align:right">April, 1898.</p>

My dear Daniel:

The 1,200 francs will be due next month and I tremble like a leaf. Nothing from either Chaudet or Mauffra—which means that I haven't a sou. Well, I screwed up my courage and flattened myself out before the

*With the Chinese (merchant).

Government officials. And I have gotten some work, the copying of building designs, for the daily wage of six francs. From that I must deduct four Sundays, the rent of a house in town and the wear on my clothes. Well—what does it matter? I must swallow my shame and do work which is ordered by the artillery guard. It is to this that Bauchy, Mauffra and his like have led me. If only I had died last month! No one can say that I have not done my best to keep afloat.

Now I have stopped painting, unless some day—which seems very improbable—things return to their normal condition.

You spoke in one of your last letters of my returning to Paris and re-entering the Bourse.

First of all I could not obtain passage at the expense of the colony. Next there are too many young Jews ready to enter the brokerage houses for them to want an old fellow of nearly fifty. And perhaps it would be more difficult to make six francs a day in Paris than it is in Papeete. And besides, all sorts of reasons make it necessary for me to remain here.

This Dutchman, Meier-Graefe, who wrote me, tells me that he has three paintings of mine. I don't know how he secured them, unless that horrible C—— sold them to him. It is possible that this unknown admirer has, in default of riches, good connections. It might be well to utilise him, if possible. Holland is an extraordinary country for the sale of pictures.

<div align="right">Always cordially,
Paul Gauguin.</div>

<div align="center">XXXIV</div>

<div align="right">July, 1898.</div>

My dear Daniel:

Like last month I have had no letter from anyone. I feel lost. Perhaps you are having trouble in the South on account of your mother. This month I am sending you by a marine officer all the canvases I have done this year; very little work as you see, and now that I am employed I can do nothing.

The large picture is partly worked over with pastel. I did that as I wanted to have it photographed. In washing that will disappear. I am really ashamed to give you so much trouble, for it will be a lot of work. As for these last pictures, they should be shown either with Bing or with Durand Ruel: or, and this would be a good thing too, at Chaudet's studio, or at yours. You should send out cards of invitation. In this way, instead of crowds one can have whom one wants, and thus gain connections that cannot harm you. I send a list of people whom I have in mind, and of course you will add any that you think desirable.

Degas, Renoir	*Revue Encyclopédique*
Portier	De la Rochefoucault
Rouart et Fils	Puvis de Chavannes
Cochin (conseiller municipal)	Mallarmé
Jean Dolent	Delaroche
Carrière	Chaplet
Coquelin	Arsène Alexandre
Roger Marx	M. et Mme. Bracquemond
Octave Mirbeau	Anatole France
Mercure de France	Paul Gallimard
Revue Blanche	de Groux
Michelet	Franz Jourdain
Geoffroy	O. Redon
Manzi	Rodin
Joyant	Vigné d'Octon

As for the large picture, do not ask too much for it on account of its size, if it can go into good hands. Talk to Lerolle about it. If Manzi, who bought the *Ia Orana Maria*, should want it, do not hesitate—he likes important pieces.

It's useless to send to Sérusier and his crowd, and to the press. Quietly, and only to those who have the right, and the cards a few days in advance. If you think best, add some of the canvases belonging to you and to Chaudet. The large canvas needs a frame, but as cheap a one as possible—a plain strip of wood, 10 centimetres wide, and white-washed so as to resemble a mural. As for the other canvases, you have frames measuring about 30. With the other things I sent last year you will have enough for a nice little exhibition.

<div align="right">Cordially,
Paul Gauguin</div>

<div align="center">* * *</div>

The little list, jotted down so casually, as the names of those who might be interested in his exhibition, is illuminating in the extreme. How many men, distinguished in the world of letters and of art, occurred familiarly to the despised exile, working here in the French Government office at six francs a day! Degas and Carrière and Renoir are there, and Rodin and Puvis de Chavannes, the greatest artists of their time. What a gathering it must have been, where Anatole France and Octave Mirbeau rubbed shoulders with Michelet, and where Mallarmé, the poet of the futurists, walked apart, thinking again perhaps of that odd phrase of his, *"tant de mystère dans tant d'éclat,"* as the enigmatic canvases glowed from their quiet places on walls.

XXXV

August 15th, 1898.

My dear Daniel:

I received your two letters and I have only a few moments in which to reply. Since this miserable war the mail comes in on a steamboat that leaves again immediately. I received also 700 francs from Chaudet. So from now on I am free of all debt here. But I must continue in this modest employment awaiting the moment of deliverance, when I can take up my brushes again, and I shall not do it until I have some money in hand. At any rate I shall be able, thanks to the relative quiet, to get back some of my health. I am much afraid of always feeling the pain in the bowels, the result of my escapade. But in spite of it, my moral state has such great influence on me, and at bottom my constitution is so robust, that perhaps I can get over it.

I am very happy you have gotten to know Degas, and that while trying to help me you were able to make a connection that may be useful to you. Ah, yes! Degas has the name of being harsh and bitter. (I, too, says Z——.)

But it is not so for those whom Degas holds worthy of his attention and esteem. He has a fine heart and he is intelligent. I am not surprised that he finds you talented and congenial. You remember doubtless that I never said anything to you of your talent until the moment when I really felt certain of it; it was not harshness, but honest frankness, and I am sure that an appreciation at such a time gave you more pleasure than the ordinary compliments that everyone receives.

Degas, both as to conduct and as to talent, is a rare example of all that an artist should be; though he has had as admirers all who are in power—Bonnat, Puvis and Antonin Proust—he has never asked for anything. From him one has never seen nor heard of a mean action, an indelicacy, or anything ugly. Art and dignity!

Evidently Rouart, who is a millionaire, did not pay a great deal for the large canvas, but if I could only sell all of them for that price, I could live and work here in perfect happiness; besides, he has a good deal of influence and his collection is supposed to be choice, a fact which may bring more buyers, an example that many dullards may follow. The buying world is so stupid, like the sheep of Panurge.

Well, however things come out, at least there seems to be some hope, and I thank you heartily for all that you have done for me. . . .

Once again my most heartfelt thanks.

Your always devoted,

Paul Gauguin

And you, too, are not happy; what can you expect? For has it not been said that this is an inevitable law for all those who are superior in either heart or brain?

XXXVI

October, 1898.

My dear Daniel:

I did not write you last month for I was in the hospital, as always, with my foot. Let's hope it was for the last time. It seems to me I am getting better, but what an expense! . . . Fortunately I have just received the 1,300 francs from you and from Chaudet. . . .

I'm waiting impatiently for news of the pictures I sent you. As for me, I'm no longer a judge of Parisian taste. Perhaps it's a good thing—I don't know. Sometimes I say to myself, "the ancients, some of them at least—painted as I do in solitude, never troubling as to what was being done around them." Yes—but on the other hand they did not have the terrible examples that we have all had before our eyes since our debut, and that, later, we have so much trouble in ridding ourselves of, to say nothing of the famous art critics, who are always trying to put one on the wrong path.

I want to ask something of you. If you have a bit of good luck with the sales, I wish you would send me a few bulbs and seeds of flowers. Simple dahlias, nasturtiums and sunflowers of various sorts, flowers that can stand the hot climate—whatever you can think of. I want to decorate my little plantation, and as you know, I adore flowers. What they have here are mostly shrubs, very few annuals—a few roses, but they do not do very well.

Now, my dear Daniel, let us hope that you are well and that nothing unfortunate has happened.

Always cordially,
Paul Gauguin

*　　*　　*

Gauguin's admiration for the gruff and surly Degas, an admiration contrasting so sharply with the sneering contempt in which he held many of his contemporaries, is striking, as an instance of the understanding of one great artist for another, though the temperaments of the two men were so dissimilar, though they lived amid such different surroundings and worked along lines so divergent. For what, outwardly, could have been wider than the gulf separating Gauguin, the mystic symbolist of *La Vision après le Sermon,* and this painter of the ballet girls and coryphées of the Parisian Opera House?

Degas was a Parisian to the finger-tips. In him there was no longing for the curious and unknown places, for a life simpler and freer, lying beyond the bounds of the Western civilisation he knew. Like some queer monk "*à rebours,*"* he lived, attended only by an old housekeeper, as crusty as himself, in the vast and dusty seclusion of his studio up three flights of rickety

*Against the grain.

staircase in the Rue Pigalle. To paint ten hours a day, to dine with a few chosen cronies at the Nouvelle Athènes, then on to the opera or music-hall, and home—such was his life. He cared nothing for gallantries or adventure. Austerely he painted and repainted his chosen models, ballet girls practising with angular, straining limbs in the grey light of a sodden afternoon, ballet girls in the white glare of the calcium—all the lure of the glittering nightlife, harsh and grotesque, despite the gilt glamour that is there. These were his chosen subjects.

"*À vous il faut la vie naturelle,*" he used to say, "*à moi la vie factice.*"*

His tongue was biting and ironical. As Gauguin understood so well, he cared nothing for glory, for the applause of the crowd. In later years he refused even to exhibit his pictures. Above all, personal notoriety and self-advertisement were distasteful to him, and is there not that famous jibe to Whistler, "My dear friend, you conduct yourself in life exactly as if you had no talent at all."

And above everything he seemed to hate critics and the whole writing crew. The idea of being the "subject" of an article made him rage.

"And did you come here to count how many shirts I have in my wardrobe?" he said once to a self-important critic, who came to him for an interview.

"My art? What do you want to say about it? Do you think you can explain the merits of a picture to those who do not see them? But among people who understand, words are not necessary. My opinion has always been the same. I think literature has only done harm to painting. You puff out the artist with vanity, you inculcate the taste for notoriety, that is all; you do not advance public taste by one jot. . . . Notwithstanding all your scribbling, it never was in a worse state than it is today. *Dites. . . ?* You do not even help us sell our pictures. A man buys a picture, not because he reads an article in a newspaper, but because he has a friend, who, he thinks, knows something about pictures, has told him it will be worth twice as much in ten years as it is today—*Dites?*"

This hatred of Degas for the critics must have seemed sweet indeed to Gauguin, for he was generally at swordpoints with them all, and spent much time, as indeed have many other artists, in concocting insulting retorts and in collecting and tabulating their stupidities. But for Degas, Manet, as well as for the great Impressionists with whom he had worked, his admiration was generous and sincere, despite all later differences of theory or technique. And Degas in turn gave Gauguin perhaps the greatest flattery that one artist can give another. For he bought his paintings for that small but choice collection with which he amused his leisure hours, and in one of the later letters Gauguin writes to Monfreid of "Degas and Rouart squabbling over his pictures at the sales."

*You need the natural life; I, the artificial.

XXXVII

Papeete, 12th December, 1898.

My dear Daniel:

The few words you wrote were awaited impatiently, I assure you. I was dreadfully uneasy, thinking you might have died, instead of seeing that you were having many difficulties with your mother, who is old and always at the point of death. Although these things are to be expected, they are none the less sad, and I sympathise with your sorrow with all my heart. This will make a great difference in your position and in your life. Have you settled things with your wife, who was making trouble over the property?

Marriage! What a calamity in our day!

Everything is dark here; there is prospect of a war with England and in consequence all the mails are delayed. And I am growing worse all the time. If I cannot hope to be cured would it not be far better to die? You reproached me so harshly for my escapade, as a thing unworthy of Gauguin. But if you knew the state of my soul after these years of suffering! If I can no longer paint, I who love only that—neither wife nor children—my heart is empty.

Am I a criminal? I don't know.

I seem condemned to live when I have lost all moral reasons for living. . . . There is no glory but that of one's own conscience. What does it matter whether the others recognise or acclaim it? There is no true satisfaction outside of one's self and just now I'm disgusted.

But let us leave this path which is too thorny and which wounds the feet.

I am impatient for the next mail, when you will speak of the pictures I sent you. I am in such a hurry to know whether I am wrong or not. For it seems to me that my large canvas must be either very good or very bad, and I know you are too masculine and too frank to tell me other than the truth about it. . . .

There must be steady work in Paris at present, and I believe that in spite of the great number of quacks and slick fellows, there will be a fine sprouting of art at the begining of the next century. Ingres, Delacroix, Corot—yes, but how many besides who are out of the running today. On the whole, there is today a fine effort and one which grows more directly out of the preceding period than did the Romantics.

I read of the death of Stéphane Mallarmé in *Le Mercure*, and was sorry to hear it. He is another who died a martyr to his art; his life was at least as beautiful as his work.

And I suppose that Fourquier and his crowd will rave over his tomb as they did over that of Manet. This society is incorrigible; one might say it does nothing but make mistakes about people on purpose while they are alive, having for watchword: Genius and Honesty . . . that is the enemy.

My best wishes to all your friends.

Cordially always,

Paul Gauguin

* * *

It was in the next month, January, 1899, that Gauguin was at last able to give up his work for the Government and to return to his home. For he wrote de Monfreid:

"I do not know how to thank you for the money you sent; it comes in time to let me return to my plantation. I was able to get in only about fifteen days' work this whole month, I suffered so with my foot.

"When shall I be better?

"You say nothing about the last pictures I sent. Did they impress you badly, or is it only that you are too busy with your own affairs just now?"

XXXVIII

Papeete, 12th January, 1899.

My dear Daniel:

For a month I have succeeded in working only fifteen days, my foot has given me such pain.

When shall I be cured?

You did well to let Delius have the picture, *Nevermore*. You remember that you reproached me for having given a title to the picture. Don't you think that the title, *Nevermore*, was the cause of this purchase, perhaps? However that may be, I am very glad that Delius is the owner.

As soon as my foot gives me some peace I shall return to work. Until that time it is useless to touch a brush. I shall do no good, spiritless and with constant interruptions. On the other hand, when I am in my ordinary condition and am in the mood, I work very quickly. At the moment, lying in bed, I work in thought. When the right moment comes I concentrate everything and execution is rapid.

And you, my dear Daniel, are looking forward to a year of business worries, away from painting. You will suffer. Write me as in the past, if not of business, at least of all that you are doing and thinking.

Paris is not as necessary to art as youth seems to think. "Keep in the stream," said Pissarro. Dangerous advice for half-men.

For fifty years, gardeners have been growing double dahlias; then, one fine day, they come back to the single dahlia.

Best wishes to all our friends and to you with all my heart,

Paul Gauguin

* * * .

The overwrought letter which follows chiefly concerns his dealings with R——, a crafty and niggardly dealer who, realising Gauguin's genius, and

foreseeing the future value of his pictures, did not scruple to take advantage of his desperate financial condition. The new exhibition had been no more successful in a monetary way than were its predecessors, and R——— managed to buy up the entire collection for a paltry sum.

<p style="text-align:center">XXXIX</p>

<p style="text-align:right">February 22nd, 1899.</p>

My dear Daniel:

The mail was twenty days late this time, and I awaited it impatiently, for I hoped that the exhibition might bring me real help. Instead of that this disastrous affair with R——— .

Certainly I'm not satisfied. Though it's not your fault, my dear Daniel; and in your place perhaps I should have done exactly the same thing. But it's really bad luck, and you know what I think of R——— . He is a crocodile of the worst sort. You say eight little canvases (really so little? they measure 30.).

And now there is nothing for sale from the whole exhibition, and R——— will have enough on hand to keep him going for a year. That means that the only people who might buy will be in R——— 's hands.

Ah, if a package of old canvases had been sold cheaply to a particular individual, it would not have done so much harm—but for R——— to have all the new ones is a real disaster.

That man is without decency, and he is quite ready to exploit one's misery just to make a few sous. I fear that next time, encouraged by this success, he will offer me half of the first price.

And that infamous C——— . Who will throw his shame in his face? And poor Chaudet, sick just at this important moment! The future looks very black to me. I'm always ill and don't know when I shall be able to work. While I had to toil at those public documents I lost a tremendous lot of time. I found my house in a dreadful condition. Rats had destroyed the roofing, and in consequence the rain had ruined many of my things. A whole set of drawings, that would have been very useful, were destroyed by cockroaches, and another large unfinished canvas was ruined by the filthy insects.

Well, I took my courage in both hands, and rather confidently, reassured by your recent success with the sales, I acted quickly—too quickly (I see it now). But unless I was to lose everything, I had to repair these misfortunes, mend the roof, stock up my wardrobe, linen, etc. I had nothing left.

I do not understand why my last canvases came in such bad condition; they must have been damaged in transport.

Much colour, you say. . . but how could I pay for it were I to spread my colours on lavishly? You can see for yourself how many metres of heavy canvas I have covered. And besides it is very dangerous to paint thickly if you are working fast. And in a hot country it's especially necessary to handle the

paint carefully; you must put it on each day as it dries, or it will be nothing but mud. And then I could only do a third as much, and at the prices I get . . .Then, too, I think that with time, and by using wax, my canvases will be much better. On my first voyage my canvases were even less highly coloured, and I think they are not the worse for it.

Excuse the incoherence of this letter, but I am terribly upset. This heavy blow about R——! I can't get it out of my head, and I cannot sleep. A new doctor has come to the hospital and seems to have taken a liking to me for some reason. He will try to cure me, but he says it will take a long time, for the malady is complicated and inveterate. The eczema is complicated by erysipelas and with a rupture of the little varicose veins.

Why did I not die last year? I shall soon be fifty years old. I'm exhausted, tired all over; my sight grows worse each day and, in consequence, the energy necessary for this constant struggle is lacking.

It will be good if you can see Degas and tell him of this trick of R——'s, for if he has bought anything from R—— or from Rouart he will see the great difference in the price, and that it would be better for me to do without any intermediaries.

Cordially yours with all my heart,

Paul Gauguin

XL

Papeete, 12th March, 1899.

My dear Daniel:

Just as I am writing, my vahine, who, despite all my misery, has returned to me, is in the pains of childbirth, and I am writing to you hastily so as not to miss the mail, in the midst of all the uproar that the event is causing. The parents are fussing about uselessly; I tell them in vain that they must wait and leave it to nature. They pay no attention—prayers come before all else.

Perhaps you, too, are presiding at a similar affair. But unfortunately a child has worse consequences for you than for me. For me it's even a good thing, for perhaps the child will make life dearer to me; life which weighs so heavily on me just now. . . .

XLI

April, 1899.

My dear Daniel:

I'm enjoying the seeds you sent me. Most of them have sprouted and will be soon in blossom. The iris, the dahlias and the gladioli are doing

wonderfully; on the other hand the anemones disappeared into the soil in a few days; I couldn't find a trace of them.

All this, together with the many flowering Tahitian shrubs, will make a veritable Eden of my house. And when I am able to paint again, if I have no imagination, I shall do some studies of the flowers. In brief, it is a great pleasure for me, and I need it, for this illness, which takes all my strength, makes my life miserable. Well, I shan't speak of it again until I am cured—it is a bore to us both.

I have thought much on what you said as to the preparation of the canvases, and the other day, while I was examining one of my old paintings, I think I found a way. I believe it comes from the poor quality of the white lead they sell here, which comes from America. It seems to be prepared with tallow. Once dry, the white lead cracks, for it doesn't stick to the canvas, and so the picture is spoilt in transport. I think I can remedy it in the future by adding linseed oil, but it would drive me mad to have to work in an oily paste.

However, I shall go into the thing thoroughly.

My regards to my friends. You no longer speak of Maillol. Does he still make masterpieces in tapestry?

> Always cordially,
> Paul Gauguin

XLII

May, '99.

My dear Daniel:

It is no use wasting time talking of that idiot Z———. What's this you say of his wife? She is asking for a divorce? I expect that she is advised by Z———'s brother, who, without seeming so, is a first-class pimp. Ah, yes; marriage. You know something about it, my poor Daniel, as do I. We do not get out of it scot free. In this noble institution there is talk of nothing but duty, honour, etc. Why don't we tell the truth, once for all? The whole question is money—prostitution, if you like. You have left everything, like me: furniture, linen, books, and all the rest. Legal sale—Enough of that. It is horrible. I have a little boy, two months old. Pretty, as is everything born of adultery. Such is the law. You have an illegitimate child who resembles you and brings you complete happiness. He cannot inherit. On the other hand, you have a legitimate child who is as like as two peas to your janitor, and is a downright ragamuffin. He inherits legitimately, after having been educated by force as his right. Moral!

Finally, you speak of my painting and give me your frank advice, as I asked. I am and am not of your opinion. So far I have put nothing on can-

vas but intention and promises. In our time there is just this great fault of treating all canvases as easel pieces. In this way many, Gustave Moreau, for instance, try to excuse their lack of imagination, of creative power, by the finesse and perfection of their craftsmanship. Through excess of emphasis there is no promise. And does not promise evoke mystery, our nature not being attuned to the absolute? It is a good thing for people to realise this danger. The Salon has made the finished picture so fashionable that sometimes one is glad to find an unfinished masterpiece in a museum; like the Corots, above all the Corots, sketched with so much charm.

You say: "Why do you not paint more thickly, so as to give a richer surface?" I do not refuse, and I should often like to do so, but it is growing more and more impossible, for I have to take the expense of materials into account. I have hardly any left, despite all my economy, and I cannot ask you for more until I have some assurance as to my means of life. If you can find anyone who will promise me 2,400 francs a year for five years, and besides that a supply of paints, I will paint thickly, or any way you like, though it takes three times as long. Now I think that perhaps after a few years, when the surface has hardened sufficiently and the oil has disappeared, you may find it to be richer. For I remember some canvases of van Gogh, among them a Brittany marine, done as thinly as possible, that he sold to Manzi. And after a few years it was almost unrecognisable and the surface was very rich.

But do not be angry if having asked your advice I do not follow it. Truly I feel sure of nothing just now. The important thing is to know whether I am on the right track, whether I am progressing, or whether I am making artistic mistakes. For after all the questions of material, of technique, even of the preparation of the canvas, are of the least importance. They can always be remedied, can't they?

But art is very terrible and difficult to fathom.

During the short period that I corrected work at the Montparnasse Studio, I said to the students: "Do not expect me to correct you directly, even if your arm is a little too long or too short—and who knows about that anyway—I shall correct only artistic faults . . . you can be precise if you care about it; with practice the craft will come almost of itself, in spite of you, and all the more easily if you think of something besides technique."

There, my dear Daniel, is my opinion, and as I reread what I have written I say to myself that I must vex you, that I am abusing your kindness, for you are good, good as good bread. Your life is not rosy nor easy, and you certainly have no need of this extra work that I am giving you all the time and that I shall still need in the future.

Forgive me for it, though you know there will be no recompense for it but that inner one—the knowledge of a good deed well done.

Greeting to friends and to you cordially,

Paul Gauguin

XLIII

June, 1899.

My dear Daniel:

Nothing from Chaudet this mail. Nothing and again nothing, which means that I shall have to get my bread on credit from the Chinaman. Not a thing to eat in the house. But it's useless to sadden you with all this. . . .

A letter from Maurice Denis asking me to exhibit in 1900 with the Symbolists, Pointillistes and *Rose Croix*. I refused, giving as my reason that I would not dare exhibit with so many of the masters I have so shamelessly copied; and then also there is the impossibility of my working in the future. Later, if this illness, which grows more cruel all of the time, should give me a moment's respite, I shall try, despite my wretchedness, to do a dozen good canvases which you can show with some of my older things—like *Ia Orana Maria*—if Manzi will loan it—at Vollard's at the same time as the exhibition of the new group.

I read an article in *Le Mercure* which is very flattering to your exhibition in general. I am glad you saw Degas, and if he wants to be warned in the future of the arrival of my new canvases, it's because he has gotten wind of R——'s speculation. Write to him. . . . I have always been afraid to, and with good cause. He would only think I was doing it for a purpose, and I know him. If he can and wants to help me, he will do it more easily and more gladly of his own volition than if I were to ask him. But, anyway, keep in touch with him as much as you can.

Will I write you next month! Just think, some of my old acquaintances, seeing me sink lower each day, especially when I had to work as foreman on the roads (oh, these colonial officials), have snubbed me. The only thing I could do was to turn my back on them haughtily, which I did, but just imagine: there was a little attorney, who wanted to play me rotten tricks, and who made it a point never to prosecute the people who stole from me. . . . Well, I decided to make an end to this sort of thing and to keep people from bothering me in the future. So I wrote the fellow a violent letter and am having it printed in the newspaper. It puts him in the position of either fighting a duel with me or of prosecuting. This letter will appear the day after the mail leaves, so I cannot tell you of the result.

If the rascal refuses to fight he will probably drag me into court, and I shall have to pay for it by a few days in prison. That would not matter, but a fine would be terrible.

This, my dear Daniel, is what happens to one in the colonies if one is hard up.

Always cordially and devotedly yours,

Paul Gauguin

XLIV

July, 1899.

My dear Daniel:

I include a newspaper clipping which will put you *au courant* with last month's skirmish. The result: nothing against me, neither duel nor prosecution. What rottenness in our colonies! However, it was high time to act, as everyone here was ready to step on my toes, thinking me to be poor. Now they begin to show, if not respect, at least a salutary fear. . . . This month there is always the same silence on Chaudet's part and I am without money. . . .

I am a little angry with you; why did you not show your bas-relief at the Durand-Ruel exhibition? There is no reason, because most of the hot-air fellows show all their turnips at every possible chance, that the other conscientious and talented artists should show an exaggerated modesty. For in that way the stinking tide will only rise the higher.

And you have a daughter; what a bother in Europe! Now I have a boy who is almost pure white and who costs no more than any animal that is nourished by its mother.

And anyhow, children do not bother me, because "I abandon them," and "I am a scoundrel of the worst sort who has deserted his wife and children."

What do I care!

With best wishes to Annette.

Cordially yours,
Paul Gauguin

XLV

August, 1899.

My dear Daniel:

Thank you for the good instructions you give me regarding the preparation of the canvases. There is no lack of oil seed here and I shall try, one of these days. When, I cannot say. I have no more canvases to paint and, besides, I am too discouraged for painting, too occupied every moment with material life. Then, what is the use, if my works are fated to pile up at your house, which must inconvenience you, or be sold to R—— for a crust of bread.

I often wonder why anyone still buys pictures, seeing that the number of painters is swelled daily by the crowd who, making no researches for themselves, quickly assimilate the researches of others and spice all according to modern taste. Commercially speaking, in art some have to wipe the plaster before the house becomes habitable.

I am sorry to hear that Maillol is fighting depression, for he is an artist and a fine fellow, so far as I know him. If elected to the Champ de Mars would he do any better? I doubt it; for in these crowds the moneybags, still more numerous than elsewhere, shut you out. His art is too distinguished to be noticed.

Look at Q——. He gets on, but behind him he has a family and a wife to pull the strings. I hope that Annette and the brat are well, as are my vahine and child.

<div style="text-align: right">Always cordially yours,
Paul Gauguin</div>

XLVI

<div style="text-align: right">September, '99.</div>

My dear Daniel:

I tried your process with the castor oil, but I do not know what the results will be. In any case, it is very difficult for me to paint in a muddy paste; for ten years ago, as you know, I painted on absorbent canvas and achieved the desired colour effects to my satisfaction. Besides, the expense was ten times less. Here it is impossible to find mucilage, at any rate for the moment we must do what we can, and what we can is not worth three shakes of a dead ram's tail.

You do not happen to know some anarchist who would care to dynamite Roujon, the Director of the Beaux Arts? If so, don't hesitate, for his replacement by Geoffroy, for example, would perhaps improve my position. For instance, a big order for designs for stained glass, that I should enjoy doing and it would give me something to eat.

Is your offspring progressing to your liking? Mine is growing visibly, and I think that he will grow into a real bull later on. In any case, he is easy to bring up. All he needs is a few linen rags, cut from our old clothes. Kind regards to Annette and to our friends.

<div style="text-align: right">Cordially yours,
Paul Gauguin</div>

XLVII

<div style="text-align: right">December, 1899.</div>

My dear Daniel:

This time the mail comes in fourteen days late. Happily a letter from you, for you missed the last two mails and I felt worried. I can see in your letter that your little girl is causing you trouble. Yes, certainly children are a great care. Not mine, however, he is growing fast and promises to be a strong and intelligent fellow.

I'm to blame also, for I took advantage of your silence and did not write. It was because at the same time each year, though I don't know why, I seem to suffer so terribly with my feet. They are incurable. And then why write of only the same thing? That I suffer and that I am again in debt. And I have good reason to feel worried—you say so yourself; you cannot be of any great help to me in the future, and with Chaudet sick—what will become of me!

I am writing to Chaudet this month, and, as he is more in the midst of things than you, I am including with it a copy of a letter from Maurice Denis, a rather curious letter, which he wrote in reply, when I refused to exhibit with him. "That Degas and Rouart scrap over my pictures, that the dealers speculate with my name, and that my canvases bring very good prices at the sales. . . ."

Great Scott! It is incomprehensible and should be looked into, for I hardly feel any recoil.

Often a bad business leads to something good. As you have seen, I begin to raise my head in Tahiti and am feeling better, as people learn to fear and respect me. Now, having gotten myself started, I have become a journalist and, truly, I did not think I had so much imagination; I am really pretty good at it. I will send you the entire series sometime. For I have founded a paper—*Le Sourire*, which I multigraph by the Edison system. It has made a great hit, but unfortunately it is passed from hand to hand, and I don't sell many copies. But, anyway, I have been making nearly fifty francs a month with it for some time, all of which helps me to keep my head on and not to get too deeply in debt. And even if I do make enemies, it is better to do that than to have people only indifferent. And I have made some interested friends (politically speaking) and have increased my credit. I am sending you a small series of wood engravings. I want to have an exhibit of pictures as well as of engravings and drawings for the World's Fair. Though they are done on any sort of wood, with my eyes growing weaker all the time, still I think they stand out forcibly from the ordinary dirty craft—but they are very imperfect. Yet I think they are interesting as art.

> In haste, very cordially,
> Paul Gauguin

<p style="text-align:center">✻ ✻ ✻</p>

It was at about this time that de Monfreid succeeded in making an arrangement with R—— for the taking over of most of Gauguin's work, for the monthly allowance of three hundred and fifty francs.

Though, during the first period of his Polynesian life, Gauguin had often wished for just such an arrangement, when it came he was dissatisfied. In reality it was only the direst poverty which made him consent to the scheme. The regular arrival of this money was a great relief after the years of anxiety through which he had passed and, though Gauguin seems to have cordially disliked the dealer and to have felt that he was getting decidedly the worst of the bargain, the comparative security he enjoyed from this time on was not to be discarded lightly.

Yet his letters betray a continual exasperation, and this was natural enough, for his fame was growing steadily and the art dealers were getting large prices for his pictures.

Besides, the death of Chaudet left all his affairs in a tangle, which eventually cost him several thousand francs, and which was never straightened out to his satisfaction.

The two following letters, despite the rather drab financial affairs with which they deal, are an interesting index to the many-sided artistic activities of the painter. Gauguin did not confine himself to a single medium. Years before, he had experimented in many of the sister crafts, sculpture, wood-carving and wood-engraving, and in ceramics, interest in which had been vastly stimulated by the Western discovery of Oriental art. Perhaps from the commencement he had felt the lure of that old Renaissance ideal, of the time when the student was not too proud to labour as an artisan in the workshop of the Master, and when the Master himself was a man of minute and painstaking craftsmanship, never despising in even the meanest technical detail any essential of his art.

From the first, woodcarving had been vastly attractive to Gauguin, and those bizarre figures, hewn from the native tree trunks, he sent back from Tahiti, those monstrous gods, instinct with the grotesque horror of the Polynesian myth, are among the most curious if not the most beautiful of his creations. The technique of all mediums was easy for him, and after his return from Martinique he turned to the study of ceramics, almost as a relaxation. He gained admission to the studio of the great Chaplet, and worked there many months, turning out a profusion of designs for quite common things, jardinières, flowerpots, tobacco jars, jewel boxes, plaques—designs always too grotesque and strange to be popular.

His great terra-cotta figure of Oviri, the Tahitian Diana, which he did during his stay in France after the first Polynesian trip, now ranks as a masterpiece, though it was literally thrown out of Chaplet's exhibition in the Salon of the Société Nationale, when Gauguin tried to show it there. It may be this figure to which he here refers, wishing to have it sent out to him for the decoration of his garden.

XLVIII

October, 1900.

My dear Daniel:

In his last letter R—— wanted to know my price for the large canvas, and he also wants to buy back a picture for 200 francs that Mauffra once offered him for 150. And he wishes to get some of the canvases that you are keeping, for 200. This makes me think that R—— wants to buy up as many as possible at a low price, so he must be watched. We must sell as many as we can over his head, but at reasonable prices, so that we can make him pay dear within a year. . . .

As you see, Chaudet's affairs must have been in great disorder and, as he did not expect to die, he probably intended some day to return what he owed me. As to the pictures and sculptures and a few van Gogh's—all things which were left at Levy's—they belong to me. Only one picture from Tahiti, *Noa Noa*, belonged to Chaudet. Then there was one large landscape that Séguin returned, and a still life, bought from Séguin's mistress. We must also find out what pictures Chaudet turned over to R——. There should be some trace of it in his books. It's a lot of trouble for you, but it is worth it, for Chaudet had my entire studio. As his mother has money, his brother ought to be in easy circumstances, and he can pay a good price. At all events my pictures and sculptures must be saved. Speaking of the sculpture, as there is very little of this work, I don't want it to be scattered, or to go into the possession of people who would not care for it. And it would give me great pleasure if you would accept (not as a present, but as a proof of my friendship) all the wood-carvings from Tahiti. The large ceramic figure that did not find a purchaser—while those ugly pot-boilers of Delaherche sell very high and go into museums—I should like to have it here for the decoration of my garden and to put upon my tomb in Tahiti. This means that as soon as you can get the money from a sale to pay for the cost of packing and freight, I should like you to send it to me. Then my little place here will be complete.

Well, misery aiding, I was forced to save up five or six thousand francs, which I now enjoy to the full. My health is better and everything is going well; so it will have to be a serious event that can now interfere with my painting.

What R—— sent me in the way of colours is almost useless, especially if I am to paint thickly; tell him so, because the paints I asked for should be the same size as the Lefranc. I tried the canvas that he sent, but it almost bewilders me, for I have become so used to an absorbent canvas. I had mastered that sort, and much of my freshness of colour was due to it. Well, I suppose I must resign myself, and learn a new craft. . . .

I am hurrying this letter into the mail as it is leaving.

<div align="right">Best wishes to you,</div>

<div align="right">Paul Gauguin</div>

<div align="center">XLIX</div>

<div align="right">January, 1901.</div>

My dear Daniel:

Your letter reaches me in the hospital, where I am suffering from influenza and from eczema of the feet, and am also spending the three hundred francs R—— sends me—when he sends them. For that brute, who is already two months behind, has the nerve to evade the subject and to lie to you about my address.

Truly it's bad luck that you can't be in Paris now, just at the business season. But no one can do the impossible.

You ask about prices for the Béziers museum? As I have told you, you have complete latitude. I know the picture you speak of and think it is good, done in one of my best moods.

As to the ceramic statue, perhaps it would be better to sell it than to send it on. Two thousand francs is not too high. Besides Mr. M—— is, I think, a connoisseur of ceramics. That atrocious Delaherche, whose things are strewn everywhere, and who has about killed ceramic art, sells his Greco-Japanese vases for just as big prices. And certainly, to say nothing of the sculpture, the Chaplet ceramics are better than the Delaherche.

Forgive me if I cut this letter short. I hardly know what is happening to me after five days' diet to lower my fever.

<div align="right">

Yours always,

Paul Gauguin

</div>

<div align="center">

L

</div>

<div align="right">

February 25, 1901.

</div>

My dear Daniel:

I have had nothing from you this month, and I think you must be busy with your mother.

Your last letter breathed a number of good hopes as to Béziers. I am coming out of the hospital this month, at least relieved, if not cured.

I have been busy hunting some wood to carve, and it is not easy in Tahiti; for though trees grow easily, they are not cultivated here as they are with us. But I finally found a panel in two pieces, about a metre in all and 4 centimetres in width. I shall have to work in relief, and the figures will be a little small on that account. It makes no difference. I hope to do something that may please Mr. M—— if my bizarreries do not frighten him. You can tell him that from now on I am working for him, so he will not be too surprised. And, of course, it does not bind him to anything.

R—— has sent me the balance of what he owes me. It seems now as though he fears that I may leave him, which shows that he is much interested in the matter. As usual, he gives no explanations. He says that he has received ten canvases and that he is thoroughly satisfied with them, but he does not say at what price he has credited them to me, at the 200 francs or at 250 which he is to pay me in the future. Without seeming to do so, see if you can clear up this question.

Best wishes to Annette.

<div align="right">

And to you with all my heart,

Paul Gauguin

</div>

LI

April, 1901.

My dear Daniel:

As I'm writing you I'm quite sick with influenza, which has been raging in Tahiti for the last two months, and which has made many ravages among us. Oh, when can I get seriously to work!

And there is another thing that is even worse; the bubonic plague, often heralded by mistake from San Francisco, has forced us to quarantine all the ships, and merchandise has almost tripled in price on account of it, which makes living more expensive here than in Paris.

And it is going to grow worse. To avoid this I am summoning all the energy that I have left and, in spite of my love for my place here, I am going to try to sell off everything I have without too much loss. Then I shall settle on one of the Marquesas Islands, where living is easy and very cheap. It will mean a loss of time, but it will be wise in the end. My contract with R—— will provide enough for my expenses and I shall find entirely new subjects there for my painting.

But until then write me as always, and I will let you know some mails in advance, about everything, and what there is to do.

And in any case do everything you can with Béziers, so that I can always have some money in advance. Another thing, as I am behindhand with R—— do not hesitate to let him have some of my old canvases if he grows impatient. Some of those, that is, that are not in reserve for the future and that you have not shown to a serious buyer. . . .

As always with all my heart,

Paul Gauguin

✻ ✻ ✻

"Well, I shall wear mourning for the Marquesas, and will probably turn up in Paris one of these days." So Gauguin had written years before to de Monfreid, just after his first trip to Tahiti on the point of sailing for home. And though the reasons given in this letter for his permanent change to these almost unknown islands might seem to have been of a purely practical sort, yet it is certain that, aside from such considerations, the stories of their wild beauty had for years intrigued his imagination.

From earliest times they had been whispered of as the home of savage tribes of surpassing ferocity and beauty. The sinister legends enveloping them were barely an exaggeration, and even yet, despite their dwindling numbers and the misery that has swept their land, the people bear a savage stamp, far deeper than the gentle Tahitians across the sea.

LII

My dear Daniel:

As the mail is leaving unexpectedly, I have only a few minutes to write you these unintelligible words, and I have many important things to tell you about. I leave next month to settle in the Marquesas, but under many difficulties. What does it matter?

For I am leaving in spite of them. I have sold my property for 5,000 francs—but here is something I had not thought of before: The stupid law does not permit one to dispose of the communal property without the consent of the wife. You can imagine my fury. To be obliged to borrow . . . so will you please ask Z—— for my wife's address and write her a letter something like this:

> Madam,
> Your husband, who contracted eczema in his broken foot after he reached Paris, is forced to return to France on the advice of his physician, if he is to recover. After having bought a piece of ground, and having built a house on it, he is now its owner, and though its value is slight it would be enough to pay, at least in part, for the expenses of the trip. Unfortunately the French law requires your signed authorisation (a legal signature) before this small property, which is classified as communal property, can be sold. I do not fear for an instant that you will make difficulties over it, as except for this all the communal property is in your hands. So would you please send me your signed authorisation immediately, so that I can reply to your husband by the next mail.

If my wife refuses to sign this authorisation, see if there is not some way to force her to do so, taking into account that all the communal goods are in her hands, though this belongs to me.

I'm sending you a copy of the bill of lading that I sent M—— so that he can get the wood-carving in Marseilles. I hope to God he will buy it, for with all the difficulties of my move to the Marquesas, I am more in need of money than ever.

It is true that I shall be ahead again in a little while, for living is almost as cheap again in the Marquesas, and besides, if I am hard up for a time I can live by hunting, and on the few vegetables I shall trouble to raise. And while speaking of gardens, try to find some seeds of different gourds for me; many of them grow in the South.

After a year, if things are going well and I am a few thousand francs ahead, I shall raise my price to R—— or he can go to the deuce.

I think that in the Marquesas, where it is easy to find models (a thing that is growing more and more difficult in Tahiti), and with new country to

explore—with new and more savage subject matter in brief—I shall do beautiful things. Here my imagination has begun to cool, and then, too, the public has grown so used to Tahiti. The world is so stupid that if one shows it canvases containing new and *terrible* elements, Tahiti will become comprehensible and charming. My Brittany pictures are now rosewater because of Tahiti; Tahiti will become eau de Cologne because of the Marquesas.

And the Degas clientele, for instance, may easily buy the Marquesas to complete their collection. Perhaps I am wrong. We shall see.

In your letter last month you spoke of the exhibition at Béziers. I think it must be the sort of thing they always give in the provinces, and I think it is more valuable for me than exhibitions in foreign countries—Brussels, or Norway—where I am like a Turk's head to the critics; and then so many of the foreign painters simply use my work to make themselves original. They make Gauguins—only better. . . .

There is nothing to be done about Chaudet. Two thousand francs thrown away. I've done all I can.

Under such circumstances what can one say or do?

Nothing.

How I have been deceived in my life!

Perhaps the city will buy something of mine at the Béziers exhibition; that is if M—— gives me a boost. It would be such a relief for the future, to sell to people who know. And what a gamble it is! Think of that picture we had thrown aside as worthless, and that you gave away to your friend, the dentist, who leaving Marseilles went to live at Béziers—and that was enough to attract a clientele. How can one calculate after that? Well! The only way is to do good work, and then sooner or later things will go well.

Criticism passes—good work remains.

Everything is in that. Unfortunately we can have only a presentiment of good work, only time can prove it and range everything in place.

Quite aside from your noble character, which always makes you dear to people who are worth anything (not to the crowd), you are talented. I am thinking of your exhibition with the Indépendants, when I was in Paris; and I think that you also should have found great support at Béziers, if not for the present at least for the future.

I should be so glad if you would tell me something about it in your letters, for I should like to know that at last you have taken the place in the world that you deserve, and that through your own merits, and not by any of the low intrigues, so much in use with the modern painters.

When you have time, in exchange for the wood-carvings which I insist on your having, I wish you could send me some little canvas of your own—a portrait for instance. I should love to have it to put in my little room in the

Marquesas. Just roll it up simply and send it to me by post. I will make a pretty little carved frame for it.

Best wishes to all your crowd.

As always, with all my heart,

Paul Gauguin

LIII

July, 1901.

My dear Daniel:

I received your letter of the 6th of May by the lucky chance of a sailing vessel. An excellent letter which promises well for next month. I had everything ready for my departure to the Marquesas, but unfortunately no letters from either you or R——, so naturally I'm hard up until the next mail.

You are foolish to worry about the canvases that you have sold over R——'s head. I did not contract with him for all of them; the maximum was twenty-five canvases.

Another thing—I had a letter from Charles Morice, in which he says that he has great hopes of getting a group of men to buy my large canvas,* and of offering it to the Luxembourg. This is very important—*if* it succeeds. So I have given him some names, such as M. M—— and Bibesco: and you might help the thing along. If they succeed it would be very helpful for the sales and would attract a large clientele. . . . Morice speaks of O. Redon as one of those interested. Has he come into any money? for Redon was far from being rich.

You must also see R—— in the event of his claiming that he owns the picture, which would be altogether false.

Yours with all my heart,

Paul Gauguin

LIV

August, 1901.

My dear Daniel:

I'm writing you this in advance, for as soon as the mail comes in I leave for the Marquesas. At last! And it has not been without a great deal of difficulty. What silly things our laws are! For, the first time I run up against them, I find

Where Do We Come From? What Are We? Where Are We Going?

them to be against all common sense, and apparently made expressly to favour the cheating of honest people. Fortunately I have a stubborn will, and after searching, questioning, etc., I found out this. That the right of the wife to the communal property is more than debatable and, besides this, that it can be annulled in a monstrous fashion. In other words, by having it registered in the mortgage bureau. And after a month, if no one has come to complain as to this registry, your property is freed of the right of mortgage. So, though admitting that the wife has the right to it, she can be deprived of this right for not having attended to the necessary things. And how could she, if she had been kept in ignorance of the matter, and so had been unable to defend herself? That is how I was able to sell my property for 4,500 francs, arrange all my affairs here, and now have enough money to settle myself comfortably in the Marquesas.

You may say that the more money I have the more I want, and I do want to sell as much now as possible. For this reason as soon as I have enough money to live on for one or two years I shall break off with R——, not brusquely, but politely. Then he will have to make up his mind to take all the old pictures at which he has been turning up his nose; and if he wants more he will have to pay a decent price for them, 500 francs, at least. Though keeping my word to him, I have no intention of allowing myself to be exploited by a gentleman who left me in the bitterest poverty for years, just to buy up my pictures for a miserable price (a premeditated trick, too, as for a long time he has been getting all that he could find from Bernard and the others).

And all this will make it easier to raise the price, and it will be easier for you to sell those we have in reserve. . . . Some time after you sell something I wish you would keep out one or two hundred francs and have some of the wood-prints well framed. You can get them from R—— .

Then when these examples are framed, either separately or two by two, show them quietly in your house and leave some with your friend in Béziers. They all belong to you, and if anyone wants them you have the whole lot to sell. Only thirty proofs were pulled from each plate and they were numbered. It is because these prints go back to the most primitive time of engraving that they are interesting. Wood-engraving for illustrations has become like photogravure, sickening. A drawing by Degas beside a copy of the drawing done by hatchers!

I am sure that in time my wood-engravings, which are so different from all the engraving being done now, will have a certain value. . . .

You must have done a fine portrait of Madame M—— .Couldn't you have it photographed? So M—— is a painter; I see his name in the catalogue. Why do you always efface yourself? It is high time that your art should help you financially. That is not commercialism, but justice. . . . I know M. Fabre. He is an admirer, but a very platonic one. As for Redon, I

am sorry at what you tell me. (He senile!) But he is still relatively young. Is it not rather that there is no worse influence for certain spirits, than the admiration of imbecile people who know nothing of art? Yes, they have told him that he is a great colourist, and it has been enough. He, who was never able to understand it! And is not his imagination exhausted, restricted as it is to one single note?

I have always said, or at least thought, that literary poetry in a painter is something special, and is neither illustration nor the translation of writing by form. In painting one must search rather for suggestion than for description, as is done in music. Sometimes people accuse me of being incomprehensible only because they look for an explicative side to my pictures that is not there. But one could chatter for a long time about all this and never come to anything definite; *ma foi,* so much the better. The critics say stupid things and we can enjoy them, if we have the legitimate feeling of superiority—the satisfaction of a duty accomplished. So many fools wish to analyse our pleasures—or at least they seem to feel that they should be allowed to enjoy them, too.

I must tell you never to register your letters to the Marquesas for I should have to make a long trip on horseback to get possession of them, and there would be many delays. There is no danger if you send money in the way I advised. La Société Commerciale (a German house) has stores in the Marquesas; its centre is in Tahiti. Do not fear that I am running into danger, for I shall be much better off in many ways (except that my correspondence will be delayed). But now it will not matter as much as formerly, especially if you have really understood me—that is if you will act with complete freedom, and without consulting me. Your intelligence and your noble heart are a sure guarantee that my affairs will be as well cared for as if I were there myself—*Sapristi*—you have certainly been working hard for eighteen months and I would be very difficult if I complained.

And when will the time come when we need speak of nothing but Art?

Best of wishes to our friends and to Annette.

Yours always with all my heart,

Paul Gauguin

* * *

It was in August or September of the year 1901 that Gauguin reached the Marquesas. Mysterious and obscure as these islands seem, mere pinpoints almost lost to sight in the vast reaches of the Pacific, it was here on the last boundaries of civilisation, at the uttermost verge of all known things, that the artist spent his few remaining years.

The history of the islands is lost in the mist of ancient legend. They lie about eight hundred miles from Tahiti, well to the northwest, and were first discovered by a Spanish Admiral, Mendana de Neyra in 1595, who gave

them their present name, Las Marquesas de Mendoza, in honour of the wife of the Peruvian Viceroy. Though he sailed on, leaving barely a trace, the beauty of the inhabitants was never quite forgotten, for Figueroa, the chronicler of Mendana's voyage, wrote on his return: "In complexion the natives are nearly white, of good stature and finely formed; and on their bodies and faces are delineated representations of fish and other devices. There came, among others, two lads paddling their canoes. They had beautiful faces and the most promising animation of countenance and were in all things so becoming that the pilot-mayor, Quiros, affirmed that nothing in his life caused him so much regret as the leaving such fine creatures to be lost in that country."

Almost two centuries later Cook touched at Fatu-hiva, and in 1813 the island of Nuku-hiva was bombarded by Captain Porter, an American, who also passed into obscurity, leaving behind only dark legends of the cruelty of the whites. It was not until 1842 that Admiral Du Petit-Thouars finally conquered the liberty-loving natives and formally annexed the islands in the name of the French Government. The fight was bloody and relentless, and since that time the populous and happy Marquesas have been given over to wretchedness and decay. Scourged by the white man's diseases, embittered and impoverished by the alien yoke, their spirits broken, their simple beliefs undermined by the advent of the missionaries, the race is now fast dwindling and within the century may completely disappear.

Like Tahiti, though in aspect harsher and more forbidding, the islands are of volcanic origin, the naked cliffs towering sheer and precipitous, two or three thousand feet above the level of the ocean. Shallow golden sands, set thick with palms and coconut trees, girdle at infrequent intervals the base of the bleak rocks, and from far off, a tangle of green-black shade, the rich inland valleys dip towards the sea. These valleys, "like a glimpse of the real Paradise come upon earth," according to the accounts of the rare travellers of early days, are now a deserted wilderness, the flourishing groves of breadfruit trees, of coconut palms, changed to gnarled and tangled jungle, utterly impenetrable. The natives, listless and spiritless, except when excited by drink, live lazily on the fruit the land affords, or sometimes fish in the adjacent waters, and since the rule of the white has come, the mortality among them has grown to terrible proportions, for now perhaps not more than a few hundred are left.

How different all this from the conditions found by Melville, the author of the fascinating *Typee*, who visited the Marquesas barely fifty years ago. Then illness seemed to be almost unknown. In truth he almost bewails the fact, fearing that it would make it impossible to see a funeral and to observe the native rites, as to which he was vastly curious. The Marquesans have always been called the most beautiful of all the South Sea peoples. "In beauty of form," says Melville, "they surpassed anything I had ever seen. Not a single instance of natural deformity was visible among them. They seemed free

from those blemishes which sometimes mar the effect of an otherwise perfect form. But their physical excellence did not merely consist in an exemption from these evils; nearly every individual could have served as a sculptor's model. The men were in almost every instance of lofty stature, scarcely ever less than six feet in height."

But even in Gauguin's time the change was apparent. Consumption, and all diseases of the lungs, the terrible elephantiasis, leprosy, and other maladies too hideous to mention, imported from Europe and the Orient, had already commenced their devastations. French colonial rule, notoriously bad as always, was rapidly destroying the native life and customs. And it is only a realization of this that can make comprehensible Gauguin's fierce detestation of priest and official alike, and the noble fight he waged against the injustices done to the natives, a fight which indirectly, though no less surely, cost him his life.

LV

Le Dominique (Hiva-Oa), Iles Marquises,

November, 1901.

My dear Daniel:

I did not write you last month as I had no news, and besides, it was pretty difficult as I was in the midst of building and of getting settled. I'm using all the furniture from my old place, and have everything any modest artist could dream of. A large studio with a little corner to sleep in; everything handy and arranged on shelves raised about two metres from the ground, where one eats, does a little carpentering and cooks. A hammock for taking a siesta sheltered from the sun, and refreshed by an ocean breeze that comes sifting through some coconut trees about three hundred metres away. Not without difficulty did I obtain half a hectare from the mission for the price of seven hundred francs. It was dear, but there was nothing else and the mission owns *everything* here.

Except for the annoyance of the priest it's perfect. I am in the centre of the village, yet no one could guess it, my house is so well surrounded by trees. Do not worry about provisions. I have an American neighbour, a charming fellow, who has a very well-stocked store, and I can get everything I need from him. I am more and more happy about my decision, and I assure you that it will be *admirable* for my painting.

And models! A beauty—I have commenced work already, though I have no more canvas. I am waiting impatiently for the supplies that R—— has been promising for more than a year, canvas and colours, White.

I am writing you ahead of time, so as not to be taken unaware when the mailboat comes in. I'm waiting for it impatiently, your silence last month making me feel that all our hopes have come to nothing in regard to Béziers. But bad luck is bad luck, isn't it?

After this mail we won't have any for two months, as the boat is going to be repaired. You will see the face I make this time if I'm short of money as usual. I'm not worrying, because from now on I shall not be a cent in debt, the sale of my property in Tahiti having cleared up everything, and I am proud of it. Z—— always said I was so improvident—well! I should like to have seen him in my place. After the terrible situation in which I have been these last few years, is it not really a *tour de force* to have come out on top and to have saved up 4,500 francs? And as things are now, especially if my health goes on improving, I need have only a little ahead to be really well off in my little fortress in the Marquesas.

I have your two September letters as well as a letter from R——. It is bad luck. You did well to let the sculpture go for 1,500 francs; unfortunately the money cannot come for three months, as we shall be left without any mail during that time on account of the repair of the boat. As if on purpose R—— tells me that he did not notice when the mailboat was to leave until it was too late, so this month's money, 350 francs, will not come for three months either.

He has sold the large canvas for 1,500 francs, and asks whether he should send me the money! It seems as though I shall never be able to work without worries, even when things are going pretty well. About the sale of the large picture, N—— writes me that little Paco had persuaded an amateur to buy it, and that R—— refused to sell it for less than 2,000 francs; then, a little later, to another amateur the price was 2,500. Just as N—— had come to talk the matter over with him, he found that the picture had been sold for 1,500!

I am glad that you were able to sell some things at Béziers, which is only fair. You are right to despise the petty glory that comes to you from the press. Your own conscience first, then the esteem of the few, the aristocrats who understand; there is nothing after that.

You know what I think of all these false ideas of symbolism, both in literature and in painting, so it's useless to repeat it. And anyway, we are agreed on that subject—and with posterity also—for healthy art will remain in spite of everything, and the lubrications of the literary critics will make no difference. Perhaps I plume myself too much for not having made any of the mistakes into which a laudatory press would have liked to force me, as it has so many others. Denis for example, Redon also, perhaps. And I smile, though rather bored, when I read so many critics who have not understood me in the least.

And here in my isolation I can grow stronger. Poetry seems to come of itself, without effort, and I need only let myself dream a little while painting to suggest it. If I can have only two years of health and of freedom from these

financial worries which have taken too great a hold upon my nervous temperament, I can reach a certain maturity in my art. I feel that I am right, but shall I have the strength to express it affirmatively?

At all events I have done my duty, and if my work does not live, at least the memory of an artist will remain, who freed painting from many of the academic shackles and from the fetters of symbolism (only another form of sentimentalism).

You will receive my letter wishing you a Happy New Year.

Noa Noa has been published without my knowledge. If you can get hold of a copy send one to me.

<div align="center">Yours as always, with all my heart,</div>
<div align="right">Paul Gauguin</div>

<div align="center">✳ ✳ ✳</div>

It was in truth a charming place, this retreat of Gauguin's in the Marquesas that he called "La Maison du Jouir."* Hidden out of sight in a leafy jungle, it stood raised high from the ground on tree trunks, its walls of split bamboo, its roof made of the laced leaves of the pandanus tree. The interior of the great studio room, which, except for a small sleeping room and a closet, comprised the entire house, was decorated fantastically in carved and painted panels, which, since brought back to France, have become famous.

"Love—and you will be happy," said one. "Be mysterious and you will be happy," the other. But for long after Gauguin's death, though his other possessions, his pictures and paints, his small reed-organ, all the simple furniture and household utensils had been taken by the officials to be sold for a few sous at auction, these panels still remained, not thought worth the trouble of removing from their high places on the walls.

A few steps from the house stood a tiny structure, a small kiosk sheltering a strange clay figure about a foot in height. It was the white man's god, the natives whispered. For each morning did he not kneel before it, as they before their own idols, so carefully hidden from the priest's prying eyes? It was indeed one of the stories in circulation about Gauguin, of which there were many both in Tahiti and the Marquesas.

"Gauguin," said some, "a fool who paints horses pink." Another, a merchant: "His affairs are going better, for he is commencing to sell—there are many fools." A judge: "Gauguin has caused us much trouble." And a pious person, the most dreadful indictment: "Each day he prostrates himself before a grotesque clay figure, and they say he worships the sun."

Victor Segalen, who visited the Marquesas a few months after Gauguin's death, found his house still standing, but empty of all save the panels, "like the

*The house of pleasure.

shell of a coconut that has been eaten by land-crabs." The kiosk, too, with its statue was untouched, but he dared not remove it, so fragile and cracked had it become from the blasting heat of the tropical sunshine. And so he left it, this queer little heathen god, the savage genius perhaps, of Gauguin, outlasting only by a little the death of its creator. About it all is crumbling. The deserted Maori homes sink beneath the creeping jungle, whose enfolding green hides softly all human traces. And in the nearby valleys the Maoris are dying. With a swiftness that has thrown terror upon even the callous white the lovely race has gone down, is vanishing utterly beneath the pressure of the alien rule. And high above, under the tropic's unheeding skies, in an unnamed grave on the grim slope of Calvary, lies the man who loved and defended them to the last, and who, through his genius, has invested them with a glory that is immortal.

LVI

March, 1902.

My dear Daniel:
 Nothing from you by this mail; but to make up for it, a nice letter from M—— which confirms what you told me as to his buying the wood-carving, with which he seems very much pleased.
 He spoke of the pictures of mine that he has—claiming three pictures; has he then bought one from R——? And a wood-carving, *Les Ondines*. I can only think of one of the old-time wood panels called "*Soyez Mystérieuses.*" Where can he have found it, except at Chaudet's before his death (he had it in storage and never spoke to me about it)?
 I have begun serious work, though I'm always ill. You can have no idea of the peace I have here in my solitude, altogether alone, and surrounded by trees. It is so restful and I was dreadfully in need of it, far from all the Tahitian officials.
 Each day I am more happy about my decision; and besides, living is not so expensive here. I pay sixty centimes for an ordinary chicken, and from time to time I get a pig weighing around twenty kilos for six or seven francs. Wine is the only thing that is really expensive, that and a few other imported commodities. And while we are on the subject of wine, couldn't Fayet, who is in the business, send out a good barrel of wine once a year? I say *good*, because any wine which is exported very far, especially to a warm country, should be a *vin ad-hoc*. It seems to me that the southern wines turn sour easily and change to vinegar.
 Of course this is always in exchange for a painting. I expect to send R—— a dozen canvases by the next mailboat. That will, I think, make me

even with him, or perhaps even a little ahead. He says that he has not received the August shipment. What a bother if it has gone wrong.

I hope that you are keeping well.

Cordially yours,
Paul Gauguin

LVII

April, 1902.

My dear Daniel:

Only two hurried words. I have had nothing from you for four mails. I fear some misfortune.

Always your devoted,
Paul Gauguin

LVIII

May, 1902.

My dear Daniel:

Your letter has come—the only one by the way, nothing from R——: but no matter. Yours sufficed. With what joy I recognised your handwriting, and how greedily I read it! All that happened naturally, of course. But I lived in deadly anxiety for two months. It's because I am no longer the Gauguin of old. These last terrible years, and my health which does not improve, have made me extremely impressionable. And in this state I seem to be without energy (and there is no one to comfort or console me). Only complete isolation.

So you are all well—you, Annette, and the child—and you will still have some fine days for painting some solid and conscientious things. Having seen the immense advances you made during my first stay in Tahiti, I can have no doubts of the progress you must have made since.

And it's all on the right track. That is to say, only that which is really one's own. And to think that there are schools to teach everyone to follow the same path as his neighbour!

You speak of my affairs: whatever you do is well done. I know M.F. He is stingy, and there is more vanity than emotion in his pictorial taste. M—— is enthusiastic about Cézanne, and he is right. But it's always the same thing, now that his pictures are expensive, now that it is good taste to understand Cézanne, now that Cézanne is a millionaire!

I seem to remember vaguely the little bas-relief that M—— has. It must be a bit of sculpture that I gave to the Comtesse de Mimal. Oh, these presents! Be wary of them, my dear fellow, for they are always sold. . . .

I sent twenty canvases to R—— last month. I hope they will have better luck than the other lot that went astray, and for which I've put in a claim.

What you say as to the collaboration of Morice in *Noa Noa* does not displease me. This collaboration has two aims. It is like most collaborations—that is with two authors working together. I wanted, when I wrote of the savages, to contrast their character with our own. And I thought it would be interesting to write—my part being that of the simple barbarian while beside it there would be the style of a cultured human being, as is that of Morice. So it was in this way that I thought of and directed the collaboration. And then, too, not being a professional writer, I wanted to see which of us was the more valuable—the naïve and brutal savage, or the decadent European. Morice even wanted to print the book out of season. And there is nothing about it which would be dishonourable for me.

While waiting for your next letter, I embrace your whole family, including the pretty little red head that shines in the garden.

Yours always,
Paul Gauguin

LIX

August 25th, 1902.

My dear Daniel:
As the Marquesas mailboat took a dive into the sea, they have thought it very witty to leave us here for eighty-five days, without mail, without news, and without flour or rice. But an obliging schooner brought us a few letters, one from you, one from M—— and two from R—— . The latter wants some of my sculpture for himself. I told him to go to you about it. From the tone of his letter (I know the fellow) I can guess that my work is selling well and that he has more and more need of it. I must admit that he is clever and is well known by lovers of good art. I strongly advised him to take the sandstone statue that you have—or is it with M—— ?—for two thousand francs. But I should rather take only 1,500 francs for it and see it go into a serious collection, like that of M—— 's, for instance.

M—— writes me that he wants to hold an important exhibition of my work next year. Perfect! I don't care about showing a great number of canvases, but I am anxious about the quality. Fortunately you will be there to look after it. If possible get the large canvas which is at Bordeaux. There is nothing at Z—— 's but a wood-carving. If possible have the *Nevermore*, which is with Delius—nothing from Brittany (Brittany is already digested, while Tahiti is there to be swallowed and sold). And you know the public. It would say right away, "What a shame he did not remain in Brittany!" You understand.

Besides, perhaps I may be there by that time, for if I must remain uncured of this chronic eczema of both feet that causes me so much suffering, it

might be better for me to return for a change of climate. Then I might settle myself near you in the South, until I am ready to go to Spain to find new subjects. The bulls, the Spaniards, their hair plastered with lard, all that has, of course, been done, overdone: and yet it's queer, but I see them differently. But what a shame it would be to leave a land as beautiful as the Marquesas.

From now on I intend to put aside everything that I make, except the 350 francs from R——. And I can do it without any trouble, for now I am not only even with him, but even a little ahead. And I can live very well here on two hundred and fifty francs, without depriving myself of anything. For living is much cheaper than in Tahiti.

In his letter M—— spoke of you and of your talent. Distrust your own opinion, we can never judge ourselves. So you cannot make a figure stand up? Well, then, let it recline, it will rest as well as yourself, and one fine day you will be able to raise it easily.

And in the meantime, go on in your peaceable enjoyment of life: our animal nature is not nearly so despicable as people would like us to believe. The mischievous Greeks, who understood all things, imagined Antæus, whose strength came back to him when he touched the earth, that is, our animal nature.

<div style="text-align:center">

Yours with all my heart,

Paul Gauguin

</div>

How stupid of me! I thought that I had no more room, and here is another page. . . .

M—— says that for my exhibition next year you should get out a pamphlet, telling of that incident with the Rouart boys, who asked Degas for an explanation of my painting at the Durand-Ruel exhibition. Degas recounted La Fontaine's fable: the dog and the wolf. Gauguin is the wolf, he said. The quotation would be nice and would serve as a good theme. And the amusing thing about it is the fact that the sheep started to follow the wolf, though the fat dogs went on barking, never getting free from their collars.

What do you think of it?

And I hope to be able to do a couple of good canvases for the exhibition.

Among the last lot of canvases that I sent R—— there was one measuring around fifty centimetres, that I think is not bad, and that is very carefully done. The poem is not clear enough—Fontainas would say! *Ma foi*, I really don't know but that I prefer the old-time criticisms of Albert Wolff. Then at least you knew where you stood, but now with all these great and precocious poets (all talented, of course) taking on a professional air with which to expound their stupidities. They no longer say: that might be, but with aplomb—that should be.

When they talk of me, one says—it's from van Gogh; another—it's from Cézanne. B—— says that it's his; another—it's Anquetin or Sérusier.

I have more "fathers" than you have!

Tell Mr. Fayet that I should have liked to reply to his flattering letter, but now I have neither the strength nor the time. He must excuse me. Perhaps some time we may meet.

<div align="center">✻ ✻ ✻</div>

Gauguin's return to France, of which he writes here to de Monfreid, could only have ended in disillusion. But the temptation was very human, and his motives are not hard to understand. The continuous suffering he endured, and which was steadily growing worse, the utter loneliness of his life, the lack of friendship and of all intellectual stimulus, which he longed for despite all his love of solitude—with what avidity did he devour his European mail!—must often have filled him with longing for the close familiarity of the life he had known, for the warmth of a friend's hand, for the sound of his native tongue. Yet it was his truest friend, de Monfried, who dissuaded him, understanding, with a coldness of vision almost resembling cruelty, the magnitude of the tragedy that might result.

In the introduction of the French edition of the Letters, written by Victor Segalen, is given a part of de Monfreid's letter in reply, and I preface it with a few lines of Segalen's text.

"But at the time when he was on the verge of self-betrayal," wrote Segalen, "of self-desertion, of leaving the land of the Maori to live elsewhere (for it was there that he was to die), Gauguin found in his correspondent, Daniel de Monfreid, the implacable guide, who led him back to the true path—who closed to him this mediocre hope, of escape, of return.

"It is all too easy to accept as friendship only the mutual rendering of service, to see in it only a method of exchanging ideas, held by both from the beginning. . . .

"But friendship holds another duty, less familiar, less easy to foresee, more difficult—that of holding the friend no matter what the cost, to the high peak of his destiny, even should that destiny be death. Georges Daniel de Monfreid did not fail. In a letter as clear-sighted as it was prophetic, Monfreid explained, and proved, that Gauguin should not, must not return home. This page, the most loyal of them all, holds an implacable decision.

" 'It is to be feared,' wrote Daniel, 'that your return would only derange the growing and slowly conceived ideas with which public opinion has surrounded you. Now you are that legendary artist, who, from out of the depths of Polynesia, sends forth his disconcerting and inimitable work—the definitive work of a man who has disappeared from the world. Your enemies (and you have many, as have all who trouble the mediocre) are now silent, do not dare to combat you, do not even think of it: for you are so far away! *You must not return. Now you are as are the great dead. You have passed into the history of art.*'

"Despite this warning and prophecy, Gauguin persisted for a time on his intended return, promising that he would only pass through Paris . . . that he would go on to Spain without delay. Then at last he resigned himself,

wrote of it no more. And yet by this departure, had it been possible in view of the expense, Gauguin would have escaped all that follows, and which, more certainly than all the maladies that weakened him, brought him to his death on the 8th day of May 1903."

LX

October, 1902.

My dear Daniel:

At last I've gotten your letter of the 5th of July. I was right in being worried about you, for you have been ill, very ill, but a cure at your age is a good sign for the future. *Non bis in idem.* * As for me, alas, I don't seem to get better, and I produce little and very poorly on account of the suffering I am in. For three mails I have had neither letters nor money from R———. Is he displeased with the last things I sent? Although they are not masterpieces they are worth easily what he is paying for them. And he has one canvas in particular that was done very carefully and that I think is good.

I am very glad to hear of what has happened to Maillol, who is a worthwhile artist.

The 600 francs that you sent came just in time. . . .

<div align="center">✳ ✳ ✳</div>

So you are going to do a portrait of M———. Try to finish it for the Béziers exhibition. There I hope that your reputation will be established.

And your wife is dying. It makes me think of mine who is *not* dying. I never have any news from her, and my children are forgetting me. Well! Little by little the wound is healing here in my solitude. And it hardly matters. After all, they could scarcely be very fond of a father who should be in jail.

Besides the four who bear my name there are other women and little children who have the right to it; and if I am famous after my death, perhaps they will say: "Yes, Gauguin had a large family, he was a patriarch." What a bitter joke!

Or, better yet: "He was a pitiless man who abandoned his children," etc. . . .

What does it matter? Let us leave the dirty *bourgeoisie*—even if they are our children—in their dirty place, and finish the work we have begun.

When this letter reaches you, probably you will have already read the article against the critics that I sent—that is if *Le Mercure* consents to publish it—I think it cannot have been displeasing to you, for I tried to prove that painters are never in need either of support or of instruction from men of

*You won't have the same trouble twice.

letters. And I also tried to hit at those people, who at nearly every epoch wrap themselves up in dogma, and try to lead astray, not only the painters but also the amateur public. When will man understand the meaning of the word *Liberty*.

You know what I have wanted to establish for so long a time. The *right* to dare everything, my own ability (and the pecuniary difficulties that were too great for such a task) have not resulted in anything very great, but in spite of all that the machine is started. The public owes me nothing, for my work is only relatively good, but the painters of the day, who are now profiting by this enfranchisement, do owe me something.

It is true that many of them think that they have accomplished everything by themselves. Well, I ask nothing of them; the recompense of my own conscience is enough. . . .

Continue to keep well, and believe me always,

<div style="text-align:center">Yours with all my heart,</div>

<div style="text-align:right">Paul Gauguin</div>

<div style="text-align:center">LXI</div>

<div style="text-align:right">February, 1903</div>

My dear Daniel:

I have just received two letters from you that were greatly delayed on account of a cyclone, such as was never seen here before. It came from the North, and we think it to be some sort of submarine upheaval. Just at the height of the diving season all the lower islands were swept by a terrible storm, and almost the whole population perished. For forty-eight hours we were deafened by thunder and rain, and then one evening the cyclone grew terrible. Though I am well protected by trees, every minute I expected my house to be swept away or torn to pieces by the wind. At ten o'clock I heard a very peculiar sound, deafening and continuous. It was the river which had burst its banks and which was seeking a new outlet. I stepped out of my room to try to see what it was, and to my vast surprise I found myself waist-deep in water. It was impossible to make out anything and to think of escape was useless. So I went back to my room and spent the night fearing that the water would come towards my poor house. Luckily I had had it built two metres higher than was absolutely necessary, and twice as strong.

In the morning I could see the terrible condition of Atuana. The bridges and roads were gone; uprooted trees everywhere (these tropical trees have very shallow roots), and ruined houses, etc.

Well, all's well that ends well, and I will get out of it with only about a hundred francs expenditures for repairs.

I don't entirely agree with you about my return to France, as I should only pass through Paris and then would go on to Spain to work there several years. Except for my friends no one need know anything about it.

No, it isn't that I am homesick, but this continuous suffering from eczema keeps me from working sanely. I have hardly touched a brush for three months. And besides, my eyesight is giving me serious trouble, and I say to myself: "What should I do if R—— threw me over—a man like me, always fighting, even against my own will, on account of my art, and surrounded by people who would be only too glad to stamp me underfoot. But in France one can hide one's misery and find pity. To be safe here I should always have from four to five thousand francs in reserve, so that in case of accident I could return.

Except for that I am well off here in my solitude.

I had a letter from Fontainas, who says that *Le Mercure* does not care to print my article. I thought as much. Well, they like to criticise painters but they do not like painters to expose their stupidity. Yet it doesn't do any harm, and for this reason: Latterly, during my long sleepless nights, I have begun to write recollections of all that I have seen, heard and thought during my lifetime: there are terrible things in my MS for some people, especially about the conduct of my wife, and of the Danes. So, though the article has not appeared, I shall put it into my book and it will only be so much the better.

Fontainas is not like N——. He is a serious man whose hands are clean, and I would be very glad if you could meet him. I am sending him my book, asking him to have it printed at any cost, and I told him to come to an agreement with you. All the pictures from my first trip to Tahiti are for sale. Get rid of the entire lot, no matter at what price. I am determined on this publication, for it will be a revenge as well as a means to make myself known and understood. Perhaps M. M—— will help you.

Mon Dieu, how many things I am asking of you! It's an outrage. Fontainas wrote: "Why do we see no more of your work? Do you despise yourself to that extent?"

From this I can see that R—— is hiding some of my things; it's an underhanded way of working that is perhaps excellent . . . but it's a little slow—for me.

I close in haste, but believe me your always devoted,

Paul Gauguin

* * *

The circumstances surrounding the last days and finally the death of Gauguin, which occurred on the morning of the 8th of May, 1903, though still obscure, have been partially brought to light by some recent investigations and by an account sent in answer to de Monfreid's inquiries by the Protestant missionary at Atuana, M. Verdier.

The exact details of that bitter quarrel with the police and with the governor are still confused. Gauguin's sympathy and pity for the oppressed native population resulted in his vehement hatred of the colonial officials, and they, in turn, as well as the priests, were scandalised by his conduct and

by his ridicule of the Catholic religion, which he made light of before the natives at every turn. And he went so far as to model an obscene image of the vicar which he exhibited in his garden, calling it—Le Père Paillard.

It was an accusation he launched against a French policeman for extorting graft payments from the natives when found distilling alcoholic drinks in the mountains, a thing forbidden by the French government, which finally brought down the wrath of the governor upon his head. In the prosecution which followed Gauguin was found guilty and sentenced to three months in prison and to a fine of 1,000 francs.

Though investigations have proved that the accusation was well founded, and though it now seems certain that his conviction could not have stood in the higher courts, especially in those of France, in the nervous and overwrought state in which Gauguin then was, the conviction came as an appalling blow. He felt it to be his ruin, and that, in his cramped financial situation, his position was desperate.

Two letters written at about this time to Charles Morice show, even more clearly than the last despairing note to de Monfreid, how bitter was his distress of mind. Yet even here, as so often even in the time of greatest stress, he wanders off, forgetful of all personal afflictions, into a discussion of abstract art.

LXII

Atuana, April, 1903.

My dear Morice:

I include the copy of a request I have made to the Inspector of the Colonies. Here in the Marquesas, not only have I had to endure the cruel suffering caused by my illness, but besides, I'm waging a terrible fight against the administration and the police. I beg you to use all your talent in getting a lot of publicity for this in the newspapers. But you must act quickly.

Monstrous things are happening in the Marquesas—and I'm on the verge of expulsion because I would not submit to a policeman, and I am accused of stirring the natives to revolt because I tell them of their rights.

A gendarme says to a native—"*Bougre de Couillon;*"* and the native, who does not understand French, says—"*Couillon toi.*"**

The native asks me to explain the meaning of *Couillon*. I do so, and they say I have not the right—and the native is put in jail.

It is a fine cause, but you must be quick, quick . . .

*Roughly, "big idiot."
**Ungrammatically, "idiot you."

LXIII

April, 1903.

My dear Morice:

As I foresaw in the article on the police which I sent you, I have been trapped by the police, and despite everything I have been found guilty. It is my ruin and perhaps it will be the same thing when I appeal. In any case it's necessary to foresee everything and to be careful. If I lose the appeal I shall go on to Paris to sue for a writ of error. I think that Delzant might have influence, and it is necessary for you to see who could protect me as soon as possible, in the Court of Appeal, in case I have to go.

You see how right I was to tell you in my last letter to act quickly and energetically. If we are victorious the struggle will have been fine and I shall have done a great thing for the Marquesas. Many iniquities will be done away with and it's worthwhile to suffer in such a cause. I am down, but not vanquished. Is the Indian vanquished who smiles at his torture? Decidedly the savage is nobler than we. You were mistaken that time when you said that I was wrong to call myself a savage. For it is true. I am a savage. And civilized people feel it to be so. All that is surprising and bewildering in my work is that "savagery that comes up in spite of myself." That is what makes my work inimitable. The work of a man is the explanation of the man. And there are two sorts of beauty; one is the result of instinct, the other of study. A combination of the two, with the resulting modifications, brings with it a very complicated richness, which the art critic ought to try to discover. Now you are an art critic. Let me not guide you, but rather advise you to open your eyes to what I want to explain, though rather mysteriously, in a few lines. The great science of Raphael does not bewilder me, nor does it in the least prevent me from feeling, seeing and understanding his foundation, which is the instinct for beauty.

Raphael was born beautiful. All else in him is simply a modification of that. We have just passed through a long period of error in art, caused by the knowledge of physical and mechanical chemistry and by the study of nature. Artists having lost their savagery, and no longer able to rely upon instinct, one might better say imagination, have strayed off on many different paths to find the productive elements they have no longer the strength to create, and now they cannot work except in disorderly crowds, feeling frightened, almost lost if left to themselves. This is why it is useless to advise solitude for everyone; one must be strong enough to endure it and to work alone. All that I learned from others has only hampered me. So I can say: no one has taught me anything. It is true I know very little. But I prefer that little which is my own. And who knows but that even this little, when exploited by others, may not become something great? How many centuries it takes to create even the appearance of movement!

Always yours,
Paul Gauguin

LXIV

April, 1903.

My dear Daniel:

I'm sending you three pictures that you will probably receive after this letter. Will you please tell M. M—— that it's a question of saving me. If the pictures do not please him, let him take others from you, or get him to lend me 1,500 francs with any guarantee he likes. The reason is this:

I am the victim of a frightful trap.

After scandalous happenings in the Marquesas I wrote to the Administrator, asking him to make an investigation. I had not thought that the police were all in connivance, that the Administrator would be on the side of the Governor, etc. The fact is that a lieutenant ordered me to be prosecuted, and a bandit of a judge, at the order of the prosecuting attorney, whom I had abused, has sentenced me (code of July '81) to three months of prison and to a fine of one thousand francs, all on account of one particular letter.

I shall have to go to Tahiti and appeal. The trip, the stay there, and above all *the expenses of a lawyer!* How much will all this cost me? It will be my ruin and the complete destruction of my health.

It will be said that all my life I have been fated to fall, only to pull myself up and to fall again. . . each day some of my old strength forsakes me.

Now attend to everything as quickly as possible, and tell Mr. M—— that I will be grateful to him forever.

With all my heart yours as always,

Paul Gauguin.

Here is the mail, and still nothing from you. For three mails R—— has neither written nor sent me money. He is actually 1,500 francs in my debt, plus payment on the pictures I sent him. In this way I now owe the Commercial Society 1,400 francs, just when I have to ask them for money to go to Tahiti.

I fear that the Society may refuse me, and then I shall be in a dreadful situation.

If R—— were dead or bankrupt I am sure you would have told me of it.

All these worries are *killing* me.

* * *

This was the last letter de Monfreid received.

A month later Gauguin was dead.

Pastor Vernier, the Protestant missionary at Atuana, was one of the few white men with whom Gauguin was at all friendly. He seems to have inspired in the artist none of the violent antagonism which he felt for the Catholic priests, and in his last illness he sent for him.

After Gauguin's death, M. Vernier wrote to de Monfreid, and his account of the painter and of his last days seems fair, almost generous, coming as it

does from this simple-hearted missionary to whom so many of the artist's sentiments as well as his way of life must have been shocking in the extreme.

"I will gladly give you some details as to the last part of the life and of the end of M. Paul Gauguin," he wrote, "all the more willingly as I cared for him until the morning of his death, which took place on the 8th of May, 1903, towards eleven in the morning. If I was not his friend—for I knew him but slightly, Gauguin being in truth a savage—I was at least his neighbour, and in consequence was quite familiar with his life. He came to see me several times and he sent for me three times, for I was something of a doctor.

"When I knew Gauguin he was ill and almost helpless. He rarely left his house, and when one did chance to meet him in the valley of Atuana he left one with a painful impression; his legs were covered with bandages and he wore the very original dress of a complete Maori, a colored pareo about the hips, his torso covered with a Tahitian shirt, his feet nearly always bare, a student's cap of green cloth on his head, with a silver ball hanging on one side. He was a very kindly man, gentle and simple with the Marquesans. And they returned his kindness. When your friend died I heard many expressions of regret from them such as this: 'Gauguin is dead. We are lost! *Ua mate Gauguin, ua pete enata!*' They alluded to the services Gauguin had often rendered them in delivering them from the clutches of the police, who were often hard and unjust towards the natives.

"Gauguin always defended them with great chivalry and generosity, and there are many proofs of his kindness towards them. He had little to do with any of the Europeans of Atuana. I think that, with a few rare exceptions, he detested them cordially. Above all he had a horror of the police and of the officials. And he had some very sharp clashes with them.

"One time (two or three months before his death) he was condemned to fifteen days in jail and to a fine of 500 francs for having insulted a policeman. Gauguin was sure of being acquitted on appeal, and was making ready to go to Tahiti when death overtook him. Gauguin felt himself to be in the right—and, anyway, he was above all that.

"He had a real cult for the country here, for this nature, so wild and beautiful in itself, where his soul found its natural frame. He was able to discover almost instantly the poetry of these regions, blest by the sun, and parts of which are still inviolate. You must have seen that in the pictures he sent you from here. The Maori soul was not mysterious for him, though Gauguin felt that our islands were daily losing a part of their originality.

" 'The Gods are dead and Atuana dies of their death,' he wrote somewhere.

"At the beginning of April, 1903, I received the following note from M. Gauguin:

" 'Dear Monsieur Vernier

" 'Would it be troubling you too much to ask you to come to see me. My eyesight seems to be going and I cannot walk. I am very ill.

" 'P. G.'

"I went to the artist's house at once. He was suffering terribly with his legs, which were red and swollen, covered with eczema. I recommended the proper medicine, and offered to dress them for him. He thanked me very pleasantly and said he would do it for himself. We talked. Forgetting his pain, he spoke of his art in an admirable way, and said that he was a misunderstood genius. He alluded to his quarrel with the police and spoke of some of his friends, though to tell you the truth I do not remember his having mentioned your name. He loaned me some books of Dolent and of Aurier, and 'L'Après Midi d'Un Faune,' which Mallarmé himself had given him. And he gave me the sketch of a portrait of the latter, with these few words—'To Monsieur Vernier . . . a piece of art. P. G.'

"I left him and did not see him again for ten days. The old Tioka, a friend of Gauguin, said to me: 'You know, things are not well with the white, he is very sick.'

"I returned to your friend and found him very low, in bed and groaning. But again he forgot his pain to speak of art. I admired this cult.

"On the 8th of May in the morning I was called again by this same Tioka. Gauguin, still in bed, complained of sharp pain in his body. He asked me whether it was morning or evening, day or night. He told me he had had two fainting spells, they frightened him. Then he spoke of Salambo. I left him lying on his back, calm and rested, after a moment's talk. Towards eleven that same morning, the young Ke Hui, his servant (alas, too intermittently, as he often deserted his master's home when he was ill), called me in great haste: 'Come, come, the white is dead.'

"I flew. I found Gauguin lifeless, one leg hanging from the bed, but he was still warm. Tioka was there, almost beside himself. 'I came to see how he was,' he said. 'I called from below Ko Ki, Ko Ki (Gauguin's native name). Hearing nothing I went up—Aie, aie! Gauguin did not move, he was dead.' And as he spoke, he bit fiercely at his friend's scalp, a Marquesas way of calling the dead to life. I tried myself the rhythmical moving of the tongue and artificial respiration, but it was useless. Paul Gauguin was dead, and all signs point to the fact that he succumbed to a sudden failure of the heart.

"I am the only European who saw Gauguin before he died. I must say that he never spoke of his family in Europe, nor did he express any last wishes. Did he leave a will? I do not think so. His papers were ransacked by the authorities and I believe that nothing was found. The rumour ran that he had a wife and five children in Europe.

"In his house there was a photograph of a family group, that represented them, so people said. I saw the photograph, but people say so many things, one did not know what to believe. Naturally, I never asked Gauguin anything about it.

"I must say a few words as to his interment and the way it happened.

"On my arrival at Gauguin's house that terrible Friday morning, when they told me he was dead, I found the Catholic bishop and several brothers of the faith were already installed there about his couch. My astonishment

was great, for everyone knew what Gauguin thought of 'Ces Messieurs,' and they knew also very well. My astonishment changed to indignation when I learned that Monsieur, the Bishop, had decided to have Gauguin buried with all Catholic pomp, and this was done on Saturday, the 9th of May. The removal of the body had been fixed for two o'clock. I wished to be present and went there at the appointed time, only to find that the body had been taken to the church an hour and a half before. A trick, as you see.

"And now Gauguin reposes in the Catholic cemetery in holy ground. To my mind Gauguin should have had only civil rites."

THE END

A CHRONOLOGICAL TABLE

Paul Gauguin born, Paris ... June 7, 1848
The Gauguin family sail for Peru ... 1852
Clovis Paul Gauguin, Senior, dies ... 1852
Gauguin family return to France, Orleans 1856
Gauguin educated in a Jesuit Seminary, Orleans 1856–65
Pilot's apprentice on *Luzitano* ... 1865
Enlists in French navy as common sailor 1868
Gauguin's mother dies .. 1869
Quits navy and joins Bertin's (bankers) .. 1871
Marries Mlle Sophie Gad .. 1873
Meets Émile Schuffenecher and begins to paint 1874
Exhibits at Salon .. 1876
Exhibits with Impressionists ... 1880, 1881
Leaves Bertin's and devotes himself to painting 1883
Removes with family to Copenhagen ... 1884
Final break with family and returns to Paris 1885
Contributes nineteen pictures to Impressionists 1886
Removes to Pont Aven, Brittany ... 1886
Meets Bernard, aged 17 ... 1886
Sails with Charles Laval to Martinique .. 1887
Returns to Paris and lives with Schuffenecher 1888
First one-man show, Paris ... 1888
Stays with van Gogh at Arles ... Oct.–Dec., 1888

Pont Aven again .. December, 1888
Volpini exhibition (Syntheticist) .. 1889
Stays with Schuffenecher .. Late 1889–90
Stays with de Monfreid .. 1890–91
Performance at Théâtre d'Art—Sale at Hôtel Drouot 1891
Sails for Tahiti ... April, 1891
Arrives Papeete ... June 8, 1891
Arrives Marseilles ... August 30, 1893
Exhibition at Durand-Ruel ... 1894
Sales of effects ... February, 1895
Leaves for Tahiti ... 1895
Attempts to commit suicide ... January, 1898
Removes to the Marquesas ... August, 1901
Condemned to imprisonment and fine April, 1903
Dies, Le Dominique, Marquesas .. May 8, 1903

A CATALOG OF SELECTED
DOVER BOOKS
IN ALL FIELDS OF INTEREST

A CATALOG OF SELECTED DOVER
BOOKS IN ALL FIELDS OF INTEREST

DRAWINGS OF REMBRANDT, edited by Seymour Slive. Updated Lippmann, Hofstede de Groot edition, with definitive scholarly apparatus. All portraits, biblical sketches, landscapes, nudes. Oriental figures, classical studies, together with selection of work by followers. 550 illustrations. Total of 630pp. 9⅛ × 12¼.
21485-0, 21486-9 Pa., Two-vol. set $29.90

GHOST AND HORROR STORIES OF AMBROSE BIERCE, Ambrose Bierce. 24 tales vividly imagined, strangely prophetic, and decades ahead of their time in technical skill: "The Damned Thing," "An Inhabitant of Carcosa," "The Eyes of the Panther," "Moxon's Master," and 20 more. 199pp. 5⅜ × 8½. 20767-6 Pa. $4.95

ETHICAL WRITINGS OF MAIMONIDES, Maimonides. Most significant ethical works of great medieval sage, newly translated for utmost precision, readability. Laws Concerning Character Traits, Eight Chapters, more. 192pp. 5⅜ × 8½.
24522-5 Pa. $4.50

THE EXPLORATION OF THE COLORADO RIVER AND ITS CANYONS, J. W. Powell. Full text of Powell's 1,000-mile expedition down the fabled Colorado in 1869. Superb account of terrain, geology, vegetation, Indians, famine, mutiny, treacherous rapids, mighty canyons, during exploration of last unknown part of continental U.S. 400pp. 5⅜ × 8½. 20094-9 Pa. $7.95

HISTORY OF PHILOSOPHY, Julián Marías. Clearest one-volume history on the market. Every major philosopher and dozens of others, to Existentialism and later. 505pp. 5⅜ × 8½. 21739-6 Pa. $9.95

ALL ABOUT LIGHTNING, Martin A. Uman. Highly readable non-technical survey of nature and causes of lightning, thunderstorms, ball lightning, St. Elmo's Fire, much more. Illustrated. 192pp. 5⅜ × 8½. 25237-X Pa. $5.95

SAILING ALONE AROUND THE WORLD, Captain Joshua Slocum. First man to sail around the world, alone, in small boat. One of great feats of seamanship told in delightful manner. 67 illustrations. 294pp. 5⅜ × 8½. 20326-3 Pa. $4.95

LETTERS AND NOTES ON THE MANNERS, CUSTOMS AND CONDITIONS OF THE NORTH AMERICAN INDIANS, George Catlin. Classic account of life among Plains Indians: ceremonies, hunt, warfare, etc. 312 plates. 572pp. of text. 6⅛ × 9¼. 22118-0, 22119-9, Pa. Two-vol. set $17.90

ALASKA: The Harriman Expedition, 1899, John Burroughs, John Muir, et al. Informative, engrossing accounts of two-month, 9,000-mile expedition. Native peoples, wildlife, forests, geography, salmon industry, glaciers, more. Profusely illustrated. 240 black-and-white line drawings. 124 black-and-white photographs. 3 maps. Index. 576pp. 5⅜ × 8½. 25109-8 Pa. $11.95

THE BOOK OF BEASTS: Being a Translation from a Latin Bestiary of the Twelfth Century, T. H. White. Wonderful catalog real and fanciful beasts: manticore, griffin, phoenix, amphivius, jaculus, many more. White's witty erudite commentary on scientific, historical aspects. Fascinating glimpse of medieval mind. Illustrated. 296pp. 5⅜ × 8¼. (Available in U.S. only)　　　24609-4 Pa. $6.95

FRANK LLOYD WRIGHT: ARCHITECTURE AND NATURE With 160 Illustrations, Donald Hoffmann. Profusely illustrated study of influence of nature—especially prairie—on Wright's designs for Fallingwater, Robie House, Guggenheim Museum, other masterpieces. 96pp. 9¼ × 10¾.　25098-9 Pa. $8.95

FRANK LLOYD WRIGHT'S FALLINGWATER, Donald Hoffmann. Wright's famous waterfall house: planning and construction of organic idea. History of site, owners, Wright's personal involvement. Photographs of various stages of building. Preface by Edgar Kaufmann, Jr. 100 illustrations. 112pp. 9¼ × 10.
　　　　　　　　　　　　　　　　　　　　　　　　　　23671-4 Pa. $8.95

YEARS WITH FRANK LLOYD WRIGHT: Apprentice to Genius, Edgar Tafel. Insightful memoir by a former apprentice presents a revealing portrait of Wright the man, the inspired teacher, the greatest American architect. 372 black-and-white illustrations. Preface. Index. vi + 228pp. 8¼ × 11.　　24801-1 Pa. $10.95

THE STORY OF KING ARTHUR AND HIS KNIGHTS, Howard Pyle. Enchanting version of King Arthur fable has delighted generations with imaginative narratives of exciting adventures and unforgettable illustrations by the author. 41 illustrations. xviii + 313pp. 6⅛ × 9¼.　　　　　21445-1 Pa. $6.95

THE GODS OF THE EGYPTIANS, E. A. Wallis Budge. Thorough coverage of numerous gods of ancient Egypt by foremost Egyptologist. Information on evolution of cults, rites and gods; the cult of Osiris; the Book of the Dead and its rites; the sacred animals and birds; Heaven and Hell; and more. 956pp. 6⅛ × 9¼.
　　　　　　　　　　　　　　22055-9, 22056-7 Pa., Two-vol. set $21.90

A THEOLOGICO-POLITICAL TREATISE, Benedict Spinoza. Also contains unfinished *Political Treatise*. Great classic on religious liberty, theory of government on common consent. R. Elwes translation. Total of 421pp. 5⅜ × 8½.
　　　　　　　　　　　　　　　　　　　　　　　　　　20249-6 Pa. $7.95

INCIDENTS OF TRAVEL IN CENTRAL AMERICA, CHIAPAS, AND YU-CATAN, John L. Stephens. Almost single-handed discovery of Maya culture; exploration of ruined cities, monuments, temples; customs of Indians. 115 drawings. 892pp. 5⅜ × 8½.　　　22404-X, 22405-8 Pa., Two-vol. set $15.90

LOS CAPRICHOS, Francisco Goya. 80 plates of wild, grotesque monsters and caricatures. Prado manuscript included. 183pp. 6⅜ × 9⅜.　　22384-1 Pa. $5.95

AUTOBIOGRAPHY: The Story of My Experiments with Truth, Mohandas K. Gandhi. Not hagiography, but Gandhi in his own words. Boyhood, legal studies, purification, the growth of the Satyagraha (nonviolent protest) movement. Critical, inspiring work of the man who freed India. 480pp. 5⅜ × 8½. (Available in U.S. only)
　　　　　　　　　　　　　　　　　　　　　　　　　　24593-4 Pa. $6.95

HOW TO WRITE, Gertrude Stein. Gertrude Stein claimed anyone could understand her unconventional writing—here are clues to help. Fascinating improvisations, language experiments, explanations illuminate Stein's craft and the art of writing. Total of 414pp. 4⅝ × 6⅜. 23144-5 Pa. $6.95

ADVENTURES AT SEA IN THE GREAT AGE OF SAIL: Five Firsthand Narratives, edited by Elliot Snow. Rare true accounts of exploration, whaling, shipwreck, fierce natives, trade, shipboard life, more. 33 illustrations. Introduction. 353pp. 5⅜ × 8½. 25177-2 Pa. $8.95

THE HERBAL OR GENERAL HISTORY OF PLANTS, John Gerard. Classic descriptions of about 2,850 plants—with over 2,700 illustrations—includes Latin and English names, physical descriptions, varieties, time and place of growth, more. 2,706 illustrations. xlv + 1,678pp. 8½ × 12¼. 23147-X Cloth. $75.00

DOROTHY AND THE WIZARD IN OZ, L. Frank Baum. Dorothy and the Wizard visit the center of the Earth, where people are vegetables, glass houses grow and Oz characters reappear. Classic sequel to *Wizard of Oz*. 256pp. 5⅜ × 8. 24714-7 Pa. $5.95

SONGS OF EXPERIENCE: Facsimile Reproduction with 26 Plates in Full Color, William Blake. This facsimile of Blake's original "Illuminated Book" reproduces 26 full-color plates from a rare 1826 edition. Includes "The Tyger," "London," "Holy Thursday," and other immortal poems. 26 color plates. Printed text of poems. 48pp. 5¼ × 7. 24636-1 Pa. $3.95

SONGS OF INNOCENCE, William Blake. The first and most popular of Blake's famous "Illuminated Books," in a facsimile edition reproducing all 31 brightly colored plates. Additional printed text of each poem. 64pp. 5¼ × 7. 22764-2 Pa. $3.95

PRECIOUS STONES, Max Bauer. Classic, thorough study of diamonds, rubies, emeralds, garnets, etc.: physical character, occurrence, properties, use, similar topics. 20 plates, 8 in color. 94 figures. 659pp. 6⅛ × 9¼. 21910-0, 21911-9 Pa., Two-vol. set $15.90

ENCYCLOPEDIA OF VICTORIAN NEEDLEWORK, S. F. A. Caulfeild and Blanche Saward. Full, precise descriptions of stitches, techniques for dozens of needlecrafts—most exhaustive reference of its kind. Over 800 figures. Total of 679pp. 8⅜ × 11. Two volumes. Vol. 1 22800-2 Pa. $11.95 Vol. 2 22801-0 Pa. $11.95

THE MARVELOUS LAND OF OZ, L. Frank Baum. Second Oz book, the Scarecrow and Tin Woodman are back with hero named Tip, Oz magic. 136 illustrations. 287pp. 5⅜ × 8½. 20692-0 Pa. $5.95

WILD FOWL DECOYS, Joel Barber. Basic book on the subject, by foremost authority and collector. Reveals history of decoy making and rigging, place in American culture, different kinds of decoys, how to make them, and how to use them. 140 plates. 156pp. 7⅞ × 10¾. 20011-6 Pa. $8.95

HISTORY OF LACE, Mrs. Bury Palliser. Definitive, profusely illustrated chronicle of lace from earliest times to late 19th century. Laces of Italy, Greece, England, France, Belgium, etc. Landmark of needlework scholarship. 266 illustrations. 672pp. 6¼ × 9¼. 24742-2 Pa. $14.95

ILLUSTRATED GUIDE TO SHAKER FURNITURE, Robert Meader. All furniture and appurtenances, with much on unknown local styles. 235 photos. 146pp. 9 × 12. 22819-3 Pa. $8.95

WHALE SHIPS AND WHALING: A Pictorial Survey, George Francis Dow. Over 200 vintage engravings, drawings, photographs of barks, brigs, cutters, other vessels. Also harpoons, lances, whaling guns, many other artifacts. Comprehensive text by foremost authority. 207 black-and-white illustrations. 288pp. 6 × 9.
24808-9 Pa. $9.95

THE BERTRAMS, Anthony Trollope. Powerful portrayal of blind self-will and thwarted ambition includes one of Trollope's most heartrending love stories. 497pp. 5⅜ × 8½. 25119-5 Pa. $9.95

ADVENTURES WITH A HAND LENS, Richard Headstrom. Clearly written guide to observing and studying flowers and grasses, fish scales, moth and insect wings, egg cases, buds, feathers, seeds, leaf scars, moss, molds, ferns, common crystals, etc.—all with an ordinary, inexpensive magnifying glass. 209 exact line drawings aid in your discoveries. 220pp. 5⅜ × 8½. 23330-8 Pa. $4.95

RODIN ON ART AND ARTISTS, Auguste Rodin. Great sculptor's candid, wide-ranging comments on meaning of art; great artists; relation of sculpture to poetry, painting, music; philosophy of life, more. 76 superb black-and-white illustrations of Rodin's sculpture, drawings and prints. 119pp. 8⅜ × 11¼. 24487-3 Pa. $7.95

FIFTY CLASSIC FRENCH FILMS, 1912-1982: A Pictorial Record, Anthony Slide. Memorable stills from Grand Illusion, Beauty and the Beast, Hiroshima, Mon Amour, many more. Credits, plot synopses, reviews, etc. 160pp. 8¼ × 11.
25256-6 Pa. $11.95

THE PRINCIPLES OF PSYCHOLOGY, William James. Famous long course complete, unabridged. Stream of thought, time perception, memory, experimental methods; great work decades ahead of its time. 94 figures. 1,391pp. 5⅜ × 8½.
20381-6, 20382-4 Pa., Two-vol. set $19.90

BODIES IN A BOOKSHOP, R. T. Campbell. Challenging mystery of blackmail and murder with ingenious plot and superbly drawn characters. In the best tradition of British suspense fiction. 192pp. 5⅜ × 8½. 24720-1 Pa. $4.95

CALLAS: PORTRAIT OF A PRIMA DONNA, George Jellinek. Renowned commentator on the musical scene chronicles incredible career and life of the most controversial, fascinating, influential operatic personality of our time. 64 black-and-white photographs. 416pp. 5⅜ × 8¼. 25047-4 Pa. $8.95

GEOMETRY, RELATIVITY AND THE FOURTH DIMENSION, Rudolph Rucker. Exposition of fourth dimension, concepts of relativity as Flatland characters continue adventures. Popular, easily followed yet accurate, profound. 141 illustrations. 133pp. 5⅜ × 8½. 23400-2 Pa. $4.95

HOUSEHOLD STORIES BY THE BROTHERS GRIMM, with pictures by Walter Crane. 53 classic stories—Rumpelstiltskin, Rapunzel, Hansel and Gretel, the Fisherman and his Wife, Snow White, Tom Thumb, Sleeping Beauty, Cinderella, and so much more—lavishly illustrated with original 19th century drawings. 114 illustrations. x + 269pp. 5⅜ × 8½. 21080-4 Pa. $4.95

THE BLUE FAIRY BOOK, Andrew Lang. The first, most famous collection, with many familiar tales: Little Red Riding Hood, Aladdin and the Wonderful Lamp, Puss in Boots, Sleeping Beauty, Hansel and Gretel, Rumpelstiltskin; 37 in all. 138 illustrations. 390pp. 5⅜ × 8½. 21437-0 Pa. $6.95

THE STORY OF THE CHAMPIONS OF THE ROUND TABLE, Howard Pyle. Sir Launcelot, Sir Tristram and Sir Percival in spirited adventures of love and triumph retold in Pyle's inimitable style. 50 drawings, 31 full-page. xviii + 329pp. 6½ × 9¼. 21883-X Pa. $7.95

THE MYTHS OF THE NORTH AMERICAN INDIANS, Lewis Spence. Myths and legends of the Algonquins, Iroquois, Pawnees and Sioux with comprehensive historical and ethnological commentary. 36 illustrations. 5⅜ × 8½.
25967-6 Pa. $8.95

GREAT DINOSAUR HUNTERS AND THEIR DISCOVERIES, Edwin H. Colbert. Fascinating, lavishly illustrated chronicle of dinosaur research, 1820's to 1960. Achievements of Cope, Marsh, Brown, Buckland, Mantell, Huxley, many others. 384pp. 5¼ × 8¼. 24701-5 Pa. $7.95

THE TASTEMAKERS, Russell Lynes. Informal, illustrated social history of American taste 1850's–1950's. First popularized categories Highbrow, Lowbrow, Middlebrow. 129 illustrations. New (1979) afterword. 384pp. 6 × 9.
23993-4 Pa. $8.95

DOUBLE CROSS PURPOSES, Ronald A. Knox. A treasure hunt in the Scottish Highlands, an old map, unidentified corpse, surprise discoveries keep reader guessing in this cleverly intricate tale of financial skullduggery. 2 black-and-white maps. 320pp. 5⅜ × 8½. (Available in U.S. only) 25032-6 Pa. $6.95

AUTHENTIC VICTORIAN DECORATION AND ORNAMENTATION IN FULL COLOR: 46 Plates from "Studies in Design," Christopher Dresser. Superb full-color lithographs reproduced from rare original portfolio of a major Victorian designer. 48pp. 9¼ × 12¼. 25083-0 Pa. $7.95

PRIMITIVE ART, Franz Boas. Remains the best text ever prepared on subject, thoroughly discussing Indian, African, Asian, Australian, and, especially, Northern American primitive art. Over 950 illustrations show ceramics, masks, totem poles, weapons, textiles, paintings, much more. 376pp. 5⅜ × 8. 20025-6 Pa. $7.95

SIDELIGHTS ON RELATIVITY, Albert Einstein. Unabridged republication of two lectures delivered by the great physicist in 1920–21. *Ether and Relativity* and *Geometry and Experience*. Elegant ideas in non-mathematical form, accessible to intelligent layman. vi + 56pp. 5⅜ × 8½. 24511-X Pa. $2.95

THE WIT AND HUMOR OF OSCAR WILDE, edited by Alvin Redman. More than 1,000 ripostes, paradoxes, wisecracks: Work is the curse of the drinking classes, I can resist everything except temptation, etc. 258pp. 5⅜ × 8½. 20602-5 Pa. $4.95

ADVENTURES WITH A MICROSCOPE, Richard Headstrom. 59 adventures with clothing fibers, protozoa, ferns and lichens, roots and leaves, much more. 142 illustrations. 232pp. 5⅜ × 8½. 23471-1 Pa. $3.95

PLANTS OF THE BIBLE, Harold N. Moldenke and Alma L. Moldenke. Standard reference to all 230 plants mentioned in Scriptures. Latin name, biblical reference, uses, modern identity, much more. Unsurpassed encyclopedic resource for scholars, botanists, nature lovers, students of Bible. Bibliography. Indexes. 123 black-and-white illustrations. 384pp. 6 × 9. 25069-5 Pa. $8.95

FAMOUS AMERICAN WOMEN: A Biographical Dictionary from Colonial Times to the Present, Robert McHenry, ed. From Pocahontas to Rosa Parks, 1,035 distinguished American women documented in separate biographical entries. Accurate, up-to-date data, numerous categories, spans 400 years. Indices. 493pp. 6½ × 9¼. 24523-3 Pa. $10.95

THE FABULOUS INTERIORS OF THE GREAT OCEAN LINERS IN HISTORIC PHOTOGRAPHS, William H. Miller, Jr. Some 200 superb photographs capture exquisite interiors of world's great "floating palaces"—1890's to 1980's: *Titanic, Ile de France, Queen Elizabeth, United States, Europa*, more. Approx. 200 black-and-white photographs. Captions. Text. Introduction. 160pp. 8⅜ × 11¼. 24756-2 Pa. $9.95

THE GREAT LUXURY LINERS, 1927–1954: A Photographic Record, William H. Miller, Jr. Nostalgic tribute to heyday of ocean liners. 186 photos of Ile de France, Normandie, Leviathan, Queen Elizabeth, United States, many others. Interior and exterior views. Introduction. Captions. 160pp. 9 × 12. 24056-8 Pa. $10.95

A NATURAL HISTORY OF THE DUCKS, John Charles Phillips. Great landmark of ornithology offers complete detailed coverage of nearly 200 species and subspecies of ducks: gadwall, sheldrake, merganser, pintail, many more. 74 full-color plates, 102 black-and-white. Bibliography. Total of 1,920pp. 8⅜ × 11¼. 25141-1, 25142-X Cloth. Two-vol. set $100.00

THE SEAWEED HANDBOOK: An Illustrated Guide to Seaweeds from North Carolina to Canada, Thomas F. Lee. Concise reference covers 78 species. Scientific and common names, habitat, distribution, more. Finding keys for easy identification. 224pp. 5⅜ × 8½. 25215-9 Pa. $6.95

THE TEN BOOKS OF ARCHITECTURE: The 1755 Leoni Edition, Leon Battista Alberti. Rare classic helped introduce the glories of ancient architecture to the Renaissance. 68 black-and-white plates. 336pp. 8⅜ × 11¼. 25239-6 Pa. $14.95

MISS MACKENZIE, Anthony Trollope. Minor masterpieces by Victorian master unmasks many truths about life in 19th-century England. First inexpensive edition in years. 392pp. 5⅜ × 8½. 25201-9 Pa. $8.95

THE RIME OF THE ANCIENT MARINER, Gustave Doré, Samuel Taylor Coleridge. Dramatic engravings considered by many to be his greatest work. The terrifying space of the open sea, the storms and whirlpools of an unknown ocean, the ice of Antarctica, more—all rendered in a powerful, chilling manner. Full text. 38 plates. 77pp. 9¼ × 12. 22305-1 Pa. $4.95

THE EXPEDITIONS OF ZEBULON MONTGOMERY PIKE, Zebulon Montgomery Pike. Fascinating first-hand accounts (1805-6) of exploration of Mississippi River, Indian wars, capture by Spanish dragoons, much more. 1,088pp. 5⅜ × 8½. 25254-X, 25255-8 Pa. Two-vol. set $25.90

A CONCISE HISTORY OF PHOTOGRAPHY: Third Revised Edition, Helmut Gernsheim. Best one-volume history—camera obscura, photochemistry, daguerreotypes, evolution of cameras, film, more. Also artistic aspects—landscape, portraits, fine art, etc. 281 black-and-white photographs. 26 in color. 176pp. 8⅜ × 11¼. 25128-4 Pa. $13.95

THE DORÉ BIBLE ILLUSTRATIONS, Gustave Doré. 241 detailed plates from the Bible: the Creation scenes, Adam and Eve, Flood, Babylon, battle sequences, life of Jesus, etc. Each plate is accompanied by the verses from the King James version of the Bible. 241pp. 9 × 12. 23004-X Pa. $9.95

WANDERINGS IN WEST AFRICA, Richard F. Burton. Great Victorian scholar/adventurer's invaluable descriptions of African tribal rituals, fetishism, culture, art, much more. Fascinating 19th-century account. 624pp. 5⅜ × 8½. 26890-X Pa. $12.95

FLATLAND, E. A. Abbott. Intriguing and enormously popular science-fiction classic explores the complexities of trying to survive as a two-dimensional being in a three-dimensional world. Amusingly illustrated by the author. 16 illustrations. 103pp. 5⅜ × 8½. 20001-9 Pa. $2.50

THE HISTORY OF THE LEWIS AND CLARK EXPEDITION, Meriwether Lewis and William Clark, edited by Elliott Coues. Classic edition of Lewis and Clark's day-by-day journals that later became the basis for U.S. claims to Oregon and the West. Accurate and invaluable geographical, botanical, biological, meteorological and anthropological material. Total of 1,508pp. 5⅜ × 8½. 21268-8, 21269-6, 21270-X Pa. Three-vol. set $26.85

LANGUAGE, TRUTH AND LOGIC, Alfred J. Ayer. Famous, clear introduction to Vienna, Cambridge schools of Logical Positivism. Role of philosophy, elimination of metaphysics, nature of analysis, etc. 160pp. 5⅜ × 8½. (Available in U.S. and Canada only) 20010-8 Pa. $3.95

MATHEMATICS FOR THE NONMATHEMATICIAN, Morris Kline. Detailed, college-level treatment of mathematics in cultural and historical context, with numerous exercises. For liberal arts students. Preface. Recommended Reading Lists. Tables. Index. Numerous black-and-white figures. xvi + 641pp. 5⅜ × 8½. 24823-2 Pa. $11.95

HANDBOOK OF PICTORIAL SYMBOLS, Rudolph Modley. 3,250 signs and symbols, many systems in full; official or heavy commercial use. Arranged by subject. Most in Pictorial Archive series. 143pp. 8⅜ × 11. 23357-X Pa. $6.95

INCIDENTS OF TRAVEL IN YUCATAN, John L. Stephens. Classic (1843) exploration of jungles of Yucatan, looking for evidences of Maya civilization. Travel adventures, Mexican and Indian culture, etc. Total of 669pp. 5⅜ × 8½. 20926-1, 20927-X Pa., Two-vol. set $11.90

DEGAS: An Intimate Portrait, Ambroise Vollard. Charming, anecdotal memoir by famous art dealer of one of the greatest 19th-century French painters. 14 black-and-white illustrations. Introduction by Harold L. Van Doren. 96pp. 5⅜ × 8½.
25131-4 Pa. $4.95

PERSONAL NARRATIVE OF A PILGRIMAGE TO ALMANDINAH AND MECCAH, Richard Burton. Great travel classic by remarkably colorful personality. Burton, disguised as a Moroccan, visited sacred shrines of Islam, narrowly escaping death. 47 illustrations. 959pp. 5⅜ × 8½. 21217-3, 21218-1 Pa., Two-vol. set $19.90

PHRASE AND WORD ORIGINS, A. H. Holt. Entertaining, reliable, modern study of more than 1,200 colorful words, phrases, origins and histories. Much unexpected information. 254pp. 5⅜ × 8½. 20758-7 Pa. $5.95

THE RED THUMB MARK, R. Austin Freeman. In this first Dr. Thorndyke case, the great scientific detective draws fascinating conclusions from the nature of a single fingerprint. Exciting story, authentic science. 320pp. 5⅜ × 8½. (Available in U.S. only) 25210-8 Pa. $6.95

AN EGYPTIAN HIEROGLYPHIC DICTIONARY, E. A. Wallis Budge. Monumental work containing about 25,000 words or terms that occur in texts ranging from 3000 B.C. to 600 A.D. Each entry consists of a transliteration of the word, the word in hieroglyphs, and the meaning in English. 1,314pp. 6⅜ × 10.
23615-3, 23616-1 Pa., Two-vol. set $35.90

THE COMPLEAT STRATEGYST: Being a Primer on the Theory of Games of Strategy, J. D. Williams. Highly entertaining classic describes, with many illustrated examples, how to select best strategies in conflict situations. Prefaces. Appendices. xvi + 268pp. 5⅜ × 8½. 25101-2 Pa. $6.95

THE ROAD TO OZ, L. Frank Baum. Dorothy meets the Shaggy Man, little Button-Bright and the Rainbow's beautiful daughter in this delightful trip to the magical Land of Oz. 272pp. 5⅜ × 8. 25208-6 Pa. $5.95

POINT AND LINE TO PLANE, Wassily Kandinsky. Seminal exposition of role of point, line, other elements in non-objective painting. Essential to understanding 20th-century art. 127 illustrations. 192pp. 6½ × 9¼. 23808-3 Pa. $5.95

LADY ANNA, Anthony Trollope. Moving chronicle of Countess Lovel's bitter struggle to win for herself and daughter Anna their rightful rank and fortune— perhaps at cost of sanity itself. 384pp. 5⅜ × 8½. 24669-8 Pa. $8.95

EGYPTIAN MAGIC, E. A. Wallis Budge. Sums up all that is known about magic in Ancient Egypt: the role of magic in controlling the gods, powerful amulets that warded off evil spirits, scarabs of immortality, use of wax images, formulas and spells, the secret name, much more. 253pp. 5⅜ × 8½. 22681-6 Pa. $4.50

THE DANCE OF SIVA, Ananda Coomaraswamy. Preeminent authority unfolds the vast metaphysic of India: the revelation of her art, conception of the universe, social organization, etc. 27 reproductions of art masterpieces. 192pp. 5⅜ × 8½.
24817-8 Pa. $5.95

CHRISTMAS CUSTOMS AND TRADITIONS, Clement A. Miles. Origin, evolution, significance of religious, secular practices. Caroling, gifts, yule logs, much more. Full, scholarly yet fascinating; non-sectarian. 400pp. 5⅜ × 8½.
23354-5 Pa. $6.95

THE HUMAN FIGURE IN MOTION, Eadweard Muybridge. More than 4,500 stopped-action photos, in action series, showing undraped men, women, children jumping, lying down, throwing, sitting, wrestling, carrying, etc. 390pp. 7⅞ × 10⅝.
20204-6 Cloth. $24.95

THE MAN WHO WAS THURSDAY, Gilbert Keith Chesterton. Witty, fast-paced novel about a club of anarchists in turn-of-the-century London. Brilliant social, religious, philosophical speculations. 128pp. 5⅜ × 8½.
25121-7 Pa. $3.95

A CEZANNE SKETCHBOOK: Figures, Portraits, Landscapes and Still Lifes, Paul Cezanne. Great artist experiments with tonal effects, light, mass, other qualities in over 100 drawings. A revealing view of developing master painter, precursor of Cubism. 102 black-and-white illustrations. 144pp. 8¾ × 6⅜.
24790-2 Pa. $6.95

AN ENCYCLOPEDIA OF BATTLES: Accounts of Over 1,560 Battles from 1479 B.C. to the Present, David Eggenberger. Presents essential details of every major battle in recorded history, from the first battle of Megiddo in 1479 B.C. to Grenada in 1984. List of Battle Maps. New Appendix covering the years 1967–1984. Index. 99 illustrations. 544pp. 6½ × 9¼.
24913-1 Pa. $14.95

AN ETYMOLOGICAL DICTIONARY OF MODERN ENGLISH, Ernest Weekley. Richest, fullest work, by foremost British lexicographer. Detailed word histories. Inexhaustible. Total of 856pp. 6½ × 9¼.
21873-2, 21874-0 Pa., Two-vol. set $19.90

WEBSTER'S AMERICAN MILITARY BIOGRAPHIES, edited by Robert McHenry. Over 1,000 figures who shaped 3 centuries of American military history. Detailed biographies of Nathan Hale, Douglas MacArthur, Mary Hallaren, others. Chronologies of engagements, more. Introduction. Addenda. 1,033 entries in alphabetical order. xi + 548pp. 6½ × 9¼. (Available in U.S. only)
24758-9 Pa. $13.95

LIFE IN ANCIENT EGYPT, Adolf Erman. Detailed older account, with much not in more recent books: domestic life, religion, magic, medicine, commerce, and whatever else needed for complete picture. Many illustrations. 597pp. 5⅜ × 8½.
22632-8 Pa. $8.95

HISTORIC COSTUME IN PICTURES, Braun & Schneider. Over 1,450 costumed figures shown, covering a wide variety of peoples: kings, emperors, nobles, priests, servants, soldiers, scholars, townsfolk, peasants, merchants, courtiers, cavaliers, and more. 256pp. 8⅜ × 11¼.
23150-X Pa. $9.95

THE NOTEBOOKS OF LEONARDO DA VINCI, edited by J. P. Richter. Extracts from manuscripts reveal great genius; on painting, sculpture, anatomy, sciences, geography, etc. Both Italian and English. 186 ms. pages reproduced, plus 500 additional drawings, including studies for *Last Supper, Sforza* monument, etc. 860pp. 7⅞ × 10¾. (Available in U.S. only) 22572-0, 22573-9 Pa., Two-vol. set $31.90

THE ART NOUVEAU STYLE BOOK OF ALPHONSE MUCHA: All 72 Plates from "Documents Decoratifs" in Original Color, Alphonse Mucha. Rare copyright-free design portfolio by high priest of Art Nouveau. Jewelry, wallpaper, stained glass, furniture, figure studies, plant and animal motifs, etc. Only complete one-volume edition. 80pp. 9⅜ × 12¼. 24044-4 Pa. $9.95

ANIMALS: 1,419 COPYRIGHT-FREE ILLUSTRATIONS OF MAMMALS, BIRDS, FISH, INSECTS, ETC., edited by Jim Harter. Clear wood engravings present, in extremely lifelike poses, over 1,000 species of animals. One of the most extensive pictorial sourcebooks of its kind. Captions. Index. 284pp. 9 × 12.
23766-4 Pa. $9.95

OBELISTS FLY HIGH, C. Daly King. Masterpiece of American detective fiction, long out of print, involves murder on a 1935 transcontinental flight—"a very thrilling story"—NY Times. Unabridged and unaltered republication of the edition published by William Collins Sons & Co. Ltd., London, 1935. 288pp. 5⅜ × 8½. (Available in U.S. only) 25036-9 Pa. $5.95

VICTORIAN AND EDWARDIAN FASHION: A Photographic Survey, Alison Gernsheim. First fashion history completely illustrated by contemporary photographs. Full text plus 235 photos, 1840–1914, in which many celebrities appear. 240pp. 6½ × 9¼. 24205-6 Pa. $8.95

THE ART OF THE FRENCH ILLUSTRATED BOOK, 1700–1914, Gordon N. Ray. Over 630 superb book illustrations by Fragonard, Delacroix, Daumier, Doré, Grandville, Manet, Mucha, Steinlen, Toulouse-Lautrec and many others. Preface. Introduction. 633 halftones. Indices of artists, authors & titles, binders and provenances. Appendices. Bibliography. 608pp. 8⅜ × 11¼. 25086-5 Pa. $24.95

THE WONDERFUL WIZARD OF OZ, L. Frank Baum. Facsimile in full color of America's finest children's classic. 143 illustrations by W. W. Denslow. 267pp. 5⅜ × 8½. 20691-2 Pa. $7.95

FOLLOWING THE EQUATOR: A Journey Around the World, Mark Twain. Great writer's 1897 account of circumnavigating the globe by steamship. Ironic humor, keen observations, vivid and fascinating descriptions of exotic places. 197 illustrations. 720pp. 5⅜ × 8½. 26113-1 Pa. $15.95

THE FRIENDLY STARS, Martha Evans Martin & Donald Howard Menzel. Classic text marshalls the stars together in an engaging, non-technical survey, presenting them as sources of beauty in night sky. 23 illustrations. Foreword. 2 star charts. Index. 147pp. 5⅜ × 8½. 21099-5 Pa. $3.95

FADS AND FALLACIES IN THE NAME OF SCIENCE, Martin Gardner. Fair, witty appraisal of cranks, quacks, and quackeries of science and pseudoscience: hollow earth, Velikovsky, orgone energy, Dianetics, flying saucers, Bridey Murphy, food and medical fads, etc. Revised, expanded In the Name of Science. "A very able and even-tempered presentation."—The New Yorker. 363pp. 5⅜ × 8.
20394-8 Pa. $6.95

ANCIENT EGYPT: ITS CULTURE AND HISTORY, J. E Manchip White. From pre-dynastics through Ptolemies: society, history, political structure, religion, daily life, literature, cultural heritage. 48 plates. 217pp. 5⅜ × 8½. 22548-8 Pa. $5.95

SIR HARRY HOTSPUR OF HUMBLETHWAITE, Anthony Trollope. Incisive, unconventional psychological study of a conflict between a wealthy baronet, his idealistic daughter, and their scapegrace cousin. The 1870 novel in its first inexpensive edition in years. 250pp. 5⅜ × 8½. 24953-0 Pa. $6.95

LASERS AND HOLOGRAPHY, Winston E. Kock. Sound introduction to burgeoning field, expanded (1981) for second edition. Wave patterns, coherence, lasers, diffraction, zone plates, properties of holograms, recent advances. 84 illustrations. 160pp. 5⅜ × 8¼. (Except in United Kingdom) 24041-X Pa. $3.95

INTRODUCTION TO ARTIFICIAL INTELLIGENCE: SECOND, EN-LARGED EDITION, Philip C. Jackson, Jr. Comprehensive survey of artificial intelligence—the study of how machines (computers) can be made to act intelligently. Includes introductory and advanced material. Extensive notes updating the main text. 132 black-and-white illustrations. 512pp. 5⅜ × 8½. 24864-X Pa. $8.95

HISTORY OF INDIAN AND INDONESIAN ART, Ananda K. Coomaraswamy. Over 400 illustrations illuminate classic study of Indian art from earliest Harappa finds to early 20th century. Provides philosophical, religious and social insights. 304pp. 6⅜ × 9⅜. 25005-9 Pa. $11.95

THE GOLEM, Gustav Meyrink. Most famous supernatural novel in modern European literature, set in Ghetto of Old Prague around 1890. Compelling story of mystical experiences, strange transformations, profound terror. 13 black-and-white illustrations. 224pp. 5⅜ × 8½. (Available in U.S. only) 25025-3 Pa. $6.95

PICTORIAL ENCYCLOPEDIA OF HISTORIC ARCHITECTURAL PLANS, DETAILS AND ELEMENTS: With 1,880 Line Drawings of Arches, Domes, Doorways, Facades, Gables, Windows, etc., John Theodore Haneman. Sourcebook of inspiration for architects, designers, others. Bibliography. Captions. 141pp. 9 × 12. 24605-1 Pa. $7.95

BENCHLEY LOST AND FOUND, Robert Benchley. Finest humor from early 30's, about pet peeves, child psychologists, post office and others. Mostly unavailable elsewhere. 73 illustrations by Peter Arno and others. 183pp. 5⅜ × 8½. 22410-4 Pa. $4.95

ERTÉ GRAPHICS, Erté. Collection of striking color graphics: *Seasons, Alphabet, Numerals, Aces* and *Precious Stones*. 50 plates, including 4 on covers. 48pp. 9⅜ × 12¼. 23580-7 Pa. $7.95

THE JOURNAL OF HENRY D. THOREAU, edited by Bradford Torrey, F. H. Allen. Complete reprinting of 14 volumes, 1837–61, over two million words; the sourcebooks for *Walden*, etc. Definitive. All original sketches, plus 75 photographs. 1,804pp. 8½ × 12¼. 20312-3, 20313-1 Cloth., Two-vol. set $125.00

CASTLES: THEIR CONSTRUCTION AND HISTORY, Sidney Toy. Traces castle development from ancient roots. Nearly 200 photographs and drawings illustrate moats, keeps, baileys, many other features. Caernarvon, Dover Castles, Hadrian's Wall, Tower of London, dozens more. 256pp. 5⅜ × 8¼. 24898-4 Pa. $6.95

CATALOG OF DOVER BOOKS

AMERICAN CLIPPER SHIPS: 1833–1858, Octavius T. Howe & Frederick C. Matthews. Fully-illustrated, encyclopedic review of 352 clipper ships from the period of America's greatest maritime supremacy. Introduction. 109 halftones. 5 black-and-white line illustrations. Index. Total of 928pp. 5⅜ × 8½.
25115-2, 25116-0 Pa., Two-vol. set $17.90

TOWARDS A NEW ARCHITECTURE, Le Corbusier. Pioneering manifesto by great architect, near legendary founder of "International School." Technical and aesthetic theories, views on industry, economics, relation of form to function, "mass-production spirit," much more. Profusely illustrated. Unabridged translation of 13th French edition. Introduction by Frederick Etchells. 320pp. 6⅛ × 9¼. (Available in U.S. only)
25023-7 Pa. $8.95

THE BOOK OF KELLS, edited by Blanche Cirker. Inexpensive collection of 32 full-color, full-page plates from the greatest illuminated manuscript of the Middle Ages, painstakingly reproduced from rare facsimile edition. Publisher's Note. Captions. 32pp. 9⅜ × 12¼.
24345-1 Pa. $4.95

BEST SCIENCE FICTION STORIES OF H. G. WELLS, H. G. Wells. Full novel *The Invisible Man*, plus 17 short stories: "The Crystal Egg," "Aepyornis Island," "The Strange Orchid," etc. 303pp. 5⅜ × 8½. (Available in U.S. only)
21531-8 Pa. $6.95

AMERICAN SAILING SHIPS: Their Plans and History, Charles G. Davis. Photos, construction details of schooners, frigates, clippers, other sailcraft of 18th to early 20th centuries—plus entertaining discourse on design, rigging, nautical lore, much more. 137 black-and-white illustrations. 240pp. 6⅛ × 9¼.
24658-2 Pa. $6.95

ENTERTAINING MATHEMATICAL PUZZLES, Martin Gardner. Selection of author's favorite conundrums involving arithmetic, money, speed, etc., with lively commentary. Complete solutions. 112pp. 5⅜ × 8½.
25211-6 Pa. $2.95

THE WILL TO BELIEVE, HUMAN IMMORTALITY, William James. Two books bound together. Effect of irrational on logical, and arguments for human immortality. 402pp. 5⅜ × 8½.
20291-7 Pa. $7.95

THE HAUNTED MONASTERY and THE CHINESE MAZE MURDERS, Robert Van Gulik. 2 full novels by Van Gulik continue adventures of Judge Dee and his companions. An evil Taoist monastery, seemingly supernatural events; overgrown topiary maze that hides strange crimes. Set in 7th-century China. 27 illustrations. 328pp. 5⅜ × 8½.
23502-5 Pa. $6.95

CELEBRATED CASES OF JUDGE DEE (DEE GOONG AN), translated by Robert Van Gulik. Authentic 18th-century Chinese detective novel; Dee and associates solve three interlocked cases. Led to Van Gulik's own stories with same characters. Extensive introduction. 9 illustrations. 237pp. 5⅜ × 8½.
23337-5 Pa. $5.95

Prices subject to change without notice.
Available at your book dealer or write for free catalog to Dept. GI, Dover Publications, Inc., 31 East 2nd St., Mineola, N.Y. 11501. Dover publishes more than 175 books each year on science, elementary and advanced mathematics, biology, music, art, literary history, social sciences and other areas.